# Homeschooling
## for Absolute
## Beginners

# Homeschooling
## for Absolute
# Beginners

## Make Learning at Home Simple, Affordable, Fun, and Effective

### Lorilee Lippincott

SKYHORSE PUBLISHING

Skyhorse Publishing books may be purchased in bulk at special discounts for sales promotion, corporate gifts, fund-raising, or educational purposes. Special editions can also be created to specifications. For details, contact the Special Sales Department, Skyhorse Publishing, 307 West 36th Street, 11th Floor, New York, NY 10018 or info@skyhorsepublishing.com.

Skyhorse® and Skyhorse Publishing® are registered trademarks of Skyhorse Publishing, Inc.®, a Delaware corporation.

Visit our website at www.skyhorsepublishing.com.

10 9 8 7 6 5 4 3 2 1

Print ISBN: 978-1-5107-6520-7
Ebook ISBN: 978-1-5107-6526-9

Cover design by Daniel Brount
Cover photo licensed from Shutterstock.com

Printed in the United States of America

This book is dedicated to my darling children who continue to live through my learning how to parent and homeschool by trial, error, and prayer. As I try to teach them to wash their faces and multiply double-digit numbers, they are teaching me about the wonders of childhood, how natural learning really is, and the joy of grasping a new concept. I love being a parent and find it a great privilege to be part of your educational journey. You are both special and brilliant, and I love you both very much!

# TABLE OF CONTENTS

# Introduction

I have to say right away that I am so excited about writing this book about simple homeschooling. It is also something "ten-years-ago" me would never believe I am doing.

Even though I homeschooled most of my first grade year, I never planned on homeschooling my kids. I believed, like so many people, that kids need socialization with lots of other kids. They need other kids for competition and motivation, and they need all the structure and schedule schooling provides.

Really, homeschooling landed in my lap as a last minute thing and it started a journey for me, my kids, and our whole family that has been amazing.

My daughter has always been a quick learner and loves books. She taught herself to read at the age of four and couldn't wait to start kindergarten. All her friends were getting ready to start, but because her birthday was not till November, she missed the cutoff to be able to start kindergarten that year.

Because she was so excited about school and academically ready, I tried to get the school to make an exception and let her start kindergarten. They tested her, and although she tested high enough

to be ready to start kindergarten if her birthday was earlier in the year, she didn't test high enough to get the exception that would allow her to bypass the October birthday cutoff.

What I had was a kid who was excited and wanting to learn—a girl whose friends were starting school—but a girl who was one month and four days too young to start with the school system.

What was I supposed to do? The kid wanted to learn—so I decided to teach her.

We set up a schoolroom in our basement that year. We had a chalkboard, a globe, and lots of crayons and glue. We didn't stick to schooling for the whole year, but by the time she was supposed to start kindergarten the following year, she was halfway through first-grade work. What was I to do? I couldn't send her to kindergarten then—she'd just be bored and frustrated.

Now she's in fourth grade and our homeschool has gone through lots of changes since that first year; we have learned tons about schooling, our kids, and ourselves, but we have never looked back.

This is my story for starting homeschooling, but there are thousands of reasons parents choose homeschooling over traditional school every year.

## Just to Be Clear

This book is not written to put down traditional education in either the public or private settings. When we started homeschooling, we had a very good public school down the street and private options we trusted. I also know and look up to many elementary teachers and believe they work hard for their students. Instead of saying one option is good and one is bad, I believe the educational system is good and necessary, but I also believe, when possible, that homeschooling could be the best option.

We chose homeschooling over the other good options, and I believe that it could be the best option for your child as well.

## Goal

The goal of this book is to encourage families who are interested in homeschooling. The basic principles of homeschooling are simple and come naturally to both kids and parents. *You can do it!*

Too many parents—me included—took in too much information and tried to do way too much in our early homeschooling years. It led to both the teacher and the students being overwhelmed, frustrated, and burned out. I hope with this book to help share with you what I have learned along the way that has changed my perspective, not only about homeschooling itself, but about homeschooling methods.

## Format

I love a good story and think it is the best way to communicate. I think talking about ideas is great sometimes, but what most of us need is real (people) examples.

Because of this, I am going to both share with you what I believe as well as the reality of how it looks in our house. I am also going to introduce you to lots more homeschooling families with different personalities, challenges, and experience levels. By sharing our stories with you, we hope to give you new ideas, encourage you, and help you know that life (and school) doesn't have to be perfect to have amazing results.

Many of the other families I share about also blog. I did this intentionally so that if there are specific stories you connect with, you can learn more about them online. Information about all the people included in this book in both case studies and quotes is at the back of the book.

Note: The goal of sharing stories of specific homeschooling families and what they do is for informational purposes only. The author and Skyhorse Publishing are neither an educational body nor able to provide legal advice for homeschooling. We encourage you

to research and find out what is required in your area. Resources for this are provided at the end of the book.

Finally, I want to thank you for picking up this book (and for reading the introduction!). I am excited to share our journey, and I am excited for the journey you are on as well. I wish you peace, purpose, stronger relationships, obedient kids, and a never-ending supply of chocolate. Let's go!

# 1

# Why Homeschool?

*"The feeling of watching my children love learning and open themselves up to knowledge that will help them to grow and develop is about as good as it gets." – Stephanie*

*"Every day feels like a huge accomplishment, because every day the boys can't wait to tell their dad what they learned at the dinner table! My favorite memories involve math concepts that finally clicked, or the day reading went from painful sounding out of letters to fluidity. I truly can't imagine missing these special moments with my children!" – Lindsey*

It seems like a pretty simple question. I get it all the time, especially when I have to explain to cashiers or librarians why my kids are running around town with me instead of going to school. But to the simple question, I don't have a simple answer. There are lots of reasons I homeschool, including:

- wanting to spend time with my kids while they are still young and building a strong family unit;

- wanting to make sure they understand my religious values and that character is more important than knowledge;
- allowing my kids to stay kids for longer and not have to sit at a desk for most of the day;
- staying away from negative peer pressure or media influences I don't think they are ready for;
- the ability to structure their learning so they can always be challenged but not overwhelmed in every subject;
- the ability for us to travel as a family;
- letting my kids have a say in what they want to learn and teaching them self-learning.

These are my reasons and I am sure you have many others.

## Homeschooling for the Right Reasons

One thing I want to caution against is homeschooling for the wrong reasons. There are homeschooling parents who keep their kids home to protect them from the world. It's natural to want to protect our children from negative things they find in school, especially when we hear more and more stories about bullying and school violence. We don't want to see our "babies" hurt. However, I believe we can hurt our kids if our primary reason for homeschooling is protection. If this is the main reason we are keeping them home, we are telling them that the world is dangerous and that they aren't ready for it; we are setting them up to be afraid of the world and to avoid it when they can. In the long run, that is not a helpful message to convey to our kids.

Granted, if you know your kids are in danger or in a bad situation in school, it might make sense to switch to homeschooling. But in most cases, putting too much emphasis on protecting your children will wind up having negative consequences. I want my children to see the world as a huge learning classroom. I want them to have confidence to go out and explore it, confidence to make many different friends

and connections with people of all ages, cultures, and economic levels. In homeschooling, I want to open the world up to my kids rather than focusing on protecting them from it.

> I want my kids to believe the world is a good place with mostly good people, while I am by their side to teach them safety and exceptions to that rule as needed.

## Can I Homeschool?

Many people I talk to believe in the homeschooling benefits and praise me for taking it on but then say, "But I could never do it." They have wanted to homeschool their children, and maybe even tried at one point, but gave up on the idea because they thought they weren't qualified.

There are three reasons I hear most frequently:

- Lack of structure
- Lack of patience
- Lack of education

I don't know you, but I do know me (and lots of other successful homeschooling moms). There are a few parents out there with elementary teaching degrees and the personality to match who love lesson planning, singing, and smiley stickers. But most of us aren't like that at all.

Many of us struggle with structure, have to learn patience during the process, and have trouble figuring out fourth-grade math problems. Many of us rarely have a day go as planned and make mistakes more than we would like to admit. We are human. Figuring out school while parenting our kids all day is something you can't get trained for in college; on-the-job training is the best you can get.

But this is life! We aren't perfect—we are on a path of growth and learning and we choose to take this path alongside our kids.

- Structure is different for every family. There is no one right way to structure your days, and what works for you right now may not work for you next week or next year. Being flexible is at least as important as being structured.
- Patience is something that's developed as it's used and tested.
- Educational support is readily available. Co-op teaching, curriculum, and Google are just a few of the tools you can utilize. (I have been known to put math problems on Facebook to get outside help within minutes.)

Whatever your concerns about homeschooling are, you should think them through carefully. But don't automatically assume you're not qualified to educate your children. You *can* homeschool, and I hope this book can help you with these areas, and more. If you believe homeschooling is best for your children, you can find a way to do it that fits your family.

## Does Homeschooling Work?

You may be wondering how homeschooled kids compare to their peers academically. Every family is different of course, but on average, homeschooled kids surpass public school children academically.

When I started homeschooling, I received a copy of *Homeschool Progress Report 2009: Academic Achievement and Demographics* from HSLDA.[1] This little booklet with only six pages was a very exciting find for me. Let me share with you some of the figures:

1. In achievement tests, homeschoolers scored (on average) in the 80s in all subjects. Public school students set the test average at 50 percent.
2. Students with a parent who is a certified teacher did not score better than students without a teacher-parent.

3. Family income and amount spent on homeschooling curriculum only had a slight correlation in test scores. The lowest-income homeschooled students still scored well above their public school peers.

These are some very encouraging statistics. As a whole, homeschooling is definitely working in this country, and the results are now here to prove it.

Kids who have been homeschooled are getting into college and even getting college scholarships. They are becoming doctors, dentists, and business owners. They are all around us in the world, creating, contributing, and changing the way society thinks.

Some days feel more successful than others, but as an educational model, we can see homeschooling really does work.

## Why Not Homeschool?

Still on the fence? Think about it in these terms: Why *not* homeschool? If you decide to give it a try, what is the worst that could happen?

Maybe your kids learn nothing, you fight all day, and you give up and send them back to school. This is unlikely, but if it were to happen, what is really lost? Maybe your kids would have to catch up on class work, but lots of kids switch schools midyear and have to deal with that. The outcome isn't really *that bad*.

But what is the best that could happen?

Take a minute to think about it. The best that could happen is limitless, different for every family, and much greater and larger than any worst-case scenario.

Not to get too touchy or personal, but I believe many parents are afraid of homeschooling their kids because they (as parents) are afraid they will fail. Our pride gets caught up in our decisions when really we should be thinking about what's best for our kids, not worrying about our own egos. Isn't it worth risking possible failure on our part (that only hurts our pride and will not cause lasting

damage to our kids) if it opens up new and beneficial possibilities for our kids?

> Can we have the confidence in our kids to give them an environment that allows them the freedom to learn and grow more freely?
>
> Can we turn the focus away from ourselves, as parents, and whether we will fail or succeed, back to our children and give them the chance and tools to have a part in their own success?

When my children finish schooling and walk out into the world on their own, I want them to have taken responsibility for their education as well as their lifelong learning. I want them to be in the habit of self-discipline and self-direction. I want them to have the confidence in themselves and their ability to learn that will allow them to dream and do big things. These deeper beliefs and habits can be taught when I believe in my kids and act as a guide to my kids in homeschooling instead of getting wrapped up in believing these decisions are about me.

## Looking to Others

At the end of every chapter, I will share with you the stories of other homeschoolers. I do this both for encouragement and to give you ideas. Every homeschooling family looks different, and I hope there will be a few families you will be able to relate to and learn from. We are all in this thing called parenting together, and it isn't about competition, but about growing a new generation of kids who will work together to make the world better. We can learn from and encourage each other so much.

*"I love learning with my kids. Seeing them grow emotionally, academically, and spiritually is amazing." – Jen*

## Case Study—Lee

I want you to meet Lee. She and her husband homeschooled their children for eight years in Seattle. When they finished their homeschool journey, both her boys received full-tuition scholarships to their first-choice universities. The financial freedom that created (because college is a pile of money) gave her the chance to pursue her dream job of helping other homeschoolers. She has even published a book on how to homeschool through high school and get a great scholarship: *The HomeScholar Guide to College Admission and Scholarships: Homeschool Secrets to Getting Ready, Getting In, and Getting Paid,*[2] which I have read and loved.

It is people like Lee who help me so much when I lack confidence. She is an amazing woman, but when I see what she has done, I think, *I could do that too.* And you can, too!

Lee and her family started homeschooling for academic reasons. They started their kids in the public school system but soon realized that they could do a better job at home. The idea wasn't foreign to them because they had friends who were homeschooling, but they were still hesitant to make the switch. In public school, their boys were performing above average in academics but weren't being challenged in the classroom.

Not only did homeschooling help provide academic challenge, but it also helped with socialization as her shy child became more confident and outgoing, both at home and in public, after she made the switch.

Lee used the Sonlight curriculum and enjoyed how it did the planning for her. She could supervise their education and be there to answer questions, but didn't have to spend hours doing lesson plans. In addition to the curriculum, both her boys were able to develop areas that interested them. Her older son became nationally ranked in chess and taught other kids chess in both private and inner-city schools. Her younger son became very involved in the local political

scene and was even offered a job as a research assistant at a public-policy think tank.

When asked how someone would know if they were successful or not in their homeschooling, she is quick to point out that it doesn't depend on how the children turn out. Children are free persons and we can't control them. As parents we do our best, try our hardest, and give everything we can to our kids. We can't be perfect, but we can give our best effort. Successful education means giving your children the best possible education in all areas that we can provide. After that education is complete, the choices are up to them.

Now that her children are past the homeschooling stage, Lee has dedicated her life to helping other families homeschool, especially during the difficult times of high school and into college. These are times when parents often lack confidence in their abilities to homeschool, but also a time in a child's life that is both fragile and full of real-life learning opportunities.

Lee and her family are proof that homeschooling really can provide amazing opportunities academically, strengthen a family, and create amazing kids.

## Case Study—Abigail

I want you to meet Abigail. Abigail is my editor at Skyhorse Publishing (who you can thank for making the book in your hands both beautiful and readable) and an amazing product of homeschooling.

Abigail homeschooled for eleven years (she graduated one year early) with her brother in an old farmhouse in southern Vermont. Back when she started, there were very few homeschoolers and they ran into a lot of opposition in the community. However, her parents had graduated their first two children through the public school system and were not happy with the education they had received. Abigail's parents did a lot of research, talked to as many people as they could, and decided to give it a try with their second two kids

(Abigail was ready for kindergarten and her brother was going into second grade).

In their community, homeschooling was very new, and Abigail struggled with stereotypes. But she loved having the freedom to pursue her interests in writing, music, and dance without having to work around a school schedule. She also had a say in what she learned. For example, one year she decided she wanted to read historical novels and do research papers on the time periods in which the books were set. She says she learned more history that year than she ever could have by memorizing dates from a textbook.

When I asked her about her experience with socialization, Abigail said that she and her brother interacted with more people of different ages than most of their peers did. They traveled, hosted foreign exchange students, and made friends with many people of different ages, religions, and socioeconomic backgrounds. When she went to college, she got involved in the community quickly.

Were Abigail's homeschool years successful? Absolutely! She explains that school years are really much more about learning to live than learning any specific collection of facts. Abigail is now the executive director of production at a New York publishing house and the author of more than a dozen books. In homeschooling, Abigail learned time management, money management, and how to be a self-motivated thinker and worker. These are the skills—much more than standardized tests can track—that make for a successful adult.

# 2

# What Is Learning?

*"Learning to add two-digit numbers is important, and I certainly want them to progress through the curriculum, but homeschooling for me is more about laying a foundation for them to become lifelong learners, so I look for signs that that's happening." – Mandi*

Often when we think of learning our mind turns to schooling. Learning is hard to put our finger on; schooling is much more tangible. We know what schooling looks like, we know how it is done, and we know how to test it for specific results. We like to see learning as schooling.

This becomes a challenge for families as they start their homeschool journey.

My homeschool journey started in our basement. My daughter had missed the age cut-off for kindergarten by thirty-five days, but she wanted to learn. I wasn't going to let thirty-five days hold her education back, so we got to work.

We cleaned out the basement of all the toys, set up a big desk, painted the walls for school, got a big chalkboard, and bought all

our school supplies. We didn't have any idea what we were doing, but I had some experience in school (about sixteen years of sitting at desks) and I knew what it looked like. Lily loved the idea of school and got really excited watching the room take shape.

Our "basement school" started at 8:00 on a Monday in August and it was very exciting. We worked through our schedule and she soaked up knowledge like a little sponge. School worked out for a few weeks like that quite nicely. And then life hit.

Life in the form of a five-year-old student, a two-year-old little brother, a messy house, appointments, and health issues. Couple these with school losing the novelty factor, and our "basement school" kind of fizzled.

Because we didn't technically have to be doing school that year, I didn't worry too much. But that year and the years after it, I learned a lot about the difference between schooling and learning.

When we started, I thought learning included:

desks
tests
worksheets
schedules
all subjects
a flag with the national anthem
recess
special lunches
field trips
smiley stickers
red pens

. . . all with clean children, cute hair, and matching clothes. I am a perfectionist at heart.

It took those first few years for me to learn that schooling and learning are not the same things. Sure, learning can happen at school, but learning could also happen without anything on my list.

Learning just needs a child with an open, imaginative mind. And most kids come born with one of those.

Children can learn to read on the lap of a parent reading stories quietly while the baby is sleeping; math can be learned in the kitchen or at the store; science is regularly learned outside or whenever an adult's back is turned (think bugs, fire, water, stains, mud, and more).

Learning can happen in many different environments, and often the best learning is hands-on and child-initiated.

One thing I learned during those first few years is that learning often comes much faster than writing. Both my children have hated worksheets but have excelled when doing things verbally. When my daughter was first doing math, we set up a huge store in the playroom with all her food and cooking items priced. First she learned single-digit addition and subtraction with different toy combinations, but then we expanded to double digits and she got to where she could "carry the extra 10 in addition" or "borrow a 10 in subtraction" all in her head.

Sitting there in the middle of all her toys watching her mind calculate $43 - 27 = 16$ accurately was amazing. It was these early experiences with learning in nontraditional school ways that really helped me understand homeschooling, believe I was capable as a parent, and have confidence in my daughter's ability to learn.

Over the years, we have used many different methods, both non-traditional and traditional, depending on the kid, the subject, and our location. However, the lesson that learning is so much more than just schooling was huge to helping me realize that this was a real option for our family.

## Home Learning

Sometimes I wish we could all agree to call homeschooling "home learning" instead. Home learning is much less intimidating.

Learning can happen while traveling, watching a nature documentary when someone is sick (or the laundry really needs to be done), or dealing with a family transition. Learning happens through birth, taking care of aging relatives, dealing with death, community service, starting a new business, and many other real-life experiences that schooling may mistake as a distraction.

Our kids need to learn to read, spell, write, do math, and have some basic ideas about history, but what they really need is to learn how to learn.

## What Are We Training Our Kids For?

In Sir Ken Robinson's speech on education from 2006[3] he hits on a very important idea—we have no idea what kind of world we are training our kids for.

Right now, we know that computer coding and security is a huge, growing field and that nurses are in demand. But if our children are just starting school at six years old now, the world they will live and work in is almost twenty years away. And that will only be the start of their working life. To properly train them for their working lives, we would need to know what will happen twenty to sixty years from now. We'd need to know what technology will be like, what jobs will be needed, what new inventions will need to be created, what political situations will be created, what languages will be the most important, and much more.

To be painfully honest, we don't have a clue.

Do our kids need more advanced math, better computer education, better environmental training, or do they need wilderness survival and disaster training? *We really don't know.*

But instead of this being a reason to stay awake all night immobilized by fear, this can free us to pursue a deeper kind of learning. What Sir Ken Robinson points out is that we need to be teaching our children creativity. Instead of teaching them the knowledge for their future lives, we need to be teaching them skills so they can adapt to whatever life brings.

This is very comforting because I can't teach my children computer coding. Instead of making computer coding a mandatory class in our homeschool, if they are interested I can find them articles, videos, and even other teachers willing to teach them. They'll learn computer coding, but more importantly, they'll learn how to find information and how to pursue their own curiosities.

When my kids leave childhood and go out on their own, I want their skills to include:

    how to learn
    curiosity
    motivation
    ability to deal with change
    self-confidence
    self-starting

Specific subjects in schooling should be used to teach these much bigger skills. Coding may be obsolete in twenty years, but none of these skills will ever become worthless no matter how the world changes. These skills make picking up and learning new skills later in life possible.

Reading, writing, and arithmetic are, and always will be, very important, but they may not be the most important things we need to teach our children. It is easy to worry about whether we are teaching the right subjects or if we have chosen the right curriculum, but these are much less important than what we are teaching our children about learning, themselves, and hard work.

> *"I had been a public school teacher for six years, and I had to unlearn some of my training to become a good homeschool teacher."*
>
> *– Kerry*

## Case Study—Joy

Let me introduce you to Joy and her husband Jeff. Jeff recently retired from being minister of music at their local church and now works with Joy from home with web/graphic design, ebook layouts, and blogging (they are a pretty talented team). Joy really helped me understand that learning is so much more than just picking up knowledge. When asked why she is homeschooling her kids, she tells people "the Maya Indians made me do it."

Joy first started homeschooling when her oldest was ready for kindergarten, but the whole experiment crashed and burned by October because of a new baby, lack of homeschooling support, and not understanding the flexibility of homeschooling. After getting her oldest set up in a good school, she decided to swear off homeschooling, figuring she wasn't cut out for it.

But then her second child hit second grade and the Maya Indians. A few months before school ended, he brought home a thick packet of worksheets on the Maya Indians that his class had been working on for a few weeks. She looked over the packet and asked him, "So, who were the Maya Indians?"

Even after much encouragement, he insisted he had no idea. She finally realized he was telling the truth. Even though he had done many worksheets and crafts, he still had no idea who the Maya Indians were. She calls this lack of true learning "worksheet mentality," which she struggled with herself.

Joy describes her own school experience in much the same way I remember mine. The teacher would assign a worksheet and it didn't matter what subject it was in, she could complete the worksheet precisely according to the directions and take a test on the material. After the test, she would promptly forget everything she had studied. Worksheet mentality is what got Joy through school with a 4.0, but she says she couldn't tell you what she learned.

She saw these same tendencies in her son. Worksheets were just a job to get done and not something to learn from. Some students might learn well this way, but it wasn't working for him.

With her husband, Joy decided they would need to make changes if they really wanted their son to learn. But do what? Private school wasn't an option, and she was hesitant to try homeschooling again.

But after reading several homeschooling books, that surfaced as the best option, and they decided to try it again. That was over nine years ago, and homeschooling has been successful and the best option for their family ever since. The process hasn't always been easy or smooth, and there are days she wants to quit. "But," she says, "I soon realize that I can't give up. I love my children, I want what's best for them, and I know that means continuing to homeschool them. I refuse to give up."

Now that she has learned and grown in her homeschooling, she says the most exciting days are the days when the work doesn't get done. Instead, it is when they end up in a spontaneous discussion or project in which each child actively participates. They can be deeply involved and not realize three hours have gone by. This, says Joy, is when the kids learn the most. No checklists, no curriculum, and no worksheets. It's homeschool bliss.

## Case Study—Nancy

First let me introduce you to Nancy, one of the most amazing ladies I know. Both she and her husband are traditional schoolteachers, and they have an amazing grasp on true learning and living experiences. Their twin boys lived in Ethiopia, Taiwan, and Malaysia before moving back to the United States when they were seven. They took their third-grade year off cycling around the United States and Mexico, but that wasn't enough biking for any of them. After doing traditional schooling for fourth grade, they took off on *The Big Trip*—cycling

for three years, a distance of seventeen thousand miles starting at the top of Alaska and going all the way to the tip of Argentina. The book she wrote about the adventure, called *Changing Gears: A Family's Odyssey to the End of the World*[4] by Nancy Rogene Sathre-Vogel, has been one of the best books I have read all year!

Their story is one of family, adventure, drive, strength, culture, and an amazing amount of education. I mean, how can you measure the amount of education a child could get from experiencing so many countries, deep in back roads and little towns, speaking and living all those cultures? You can't. Where other kids learn geography and history, Nancy and her boys were learning hands-on. Where other kids learn languages in a classroom, her boys were living in it, playing in it, and relying on it to eat.

Kids in these situations don't need to be told to study or drilled with flashcards—they are soaking up learning because it is interesting and practical.

Nancy and her family didn't decide to homeschool because of education; they made the decision based on lifestyle. The lifestyle they wanted to lead and the benefits they were looking for didn't fit into the traditional model of education they knew well and respected. They were living the idea that life is about learning, and that learning can fit into every aspect of life.

When they returned from their trip after being away from school for three years, were they behind in traditional schoolwork? Not at all. Learning happens everywhere, and the more children have opportunities to explore, the faster they pick up on everything.

After returning, Nancy and her husband worked with the school system and their sons to come up with the best program for their kids. It involved taking advanced science and math classes at the school and homeschooling the rest. How school fits into their past, present, and their future, has and will always be something they choose as a family.

What Nancy and her husband have taught their kids goes much further than just academics. They have taught them courage, determination, and that they can do anything they set their minds to. I am sure when they face challenges in the future, they will be able to look at them with confidence and move forward, just like they did on their bikes.

3

# Starting a Simple Homeschool

*"I love that I get to know my kids so well! I appreciate them so much more when I see how they learn and what they love. My least favorite part is that it really is a lot of work – but it's worth it!" – Linsey*

So, if you are ready to give homeschooling a try, or give it a second chance, what is the next step? Maybe you have done "basement school" unsuccessfully and wanted to give up. Maybe you know other people who have given homeschooling a bad name. Maybe your self-confidence is low. Maybe those close to you, friends or family, are not supportive of the decision.

What do you do? How do you start?

I believe every change in life needs to start in the mind and on paper before it can be acted on. When we act before we know our destination, things become confusing and crazy. I believe homeschooling can be simple, but only if our purpose and goals are clear.

Simple is not always easy. I would be lying if I said homeschooling was easy. Parenting isn't easy, so nothing that includes that element could ever be easy—but it can be simple and it is definitely worth it.

Before making the decision to start, or before getting too excited about which method or schedule to adopt, I want you to do some thinking and dreaming.

- What do you want your kids to be like when they step into adulthood?
- What work skills do you want them to have?
- What life skills will they need to have?
- What friends and connections do you want them to be looking for?
- What do you want them to believe about themselves and the world around them?
- What do you want your relationship with them to be like?
- How do you want them to evaluate their success?

This is your end result.

Now think about your children now.

- What do you want their lives to be like now?
- What things do you want them to be working on?
- What things do they want to be working on?
- What things do you want them to be worrying about?
- What does it mean for them to be happy and healthy now?
- What do you want them to value?
- How do you want them to evaluate their success?

These are some big questions, so don't rush through them. Talk with your spouse, a close friend, or even your child (if age appropriate). The answers for these questions will help you create the school environment you want for your child and will help you evaluate if it is successful or not.

This is so important. As parents, we can get upset when our kids fall behind in a subject or struggle to grasp a concept. We can feel like a failure if a workbook doesn't get done or if school gets interrupted. But these aren't the things we should be evaluating our schooling on.

We need to evaluate the success of our homeschooling on things much bigger and much deeper than worksheet pages or even standardized tests. It is proven that all kids develop and are ready for subjects at different times. Things like math and reading can fluctuate over the years and are not always a good indicator of academic or homeschooling success.

However, these answers point to what is most important for you and your family to teach. The results may be harder to measure, but they are far more important.

Because we sometimes get so confused with schooling and learning, let's start with the end result. With your notes from the above questions, I want you to close your eyes and dream about what your successful homeschool would look like. Picture your eighteen-year-olds graduating.

- What do they look like?
- What do they talk like?
- What might their week look like?
- Who would their friends be?
- What would they say to you?
- What would you say to them?

Now work back from that point. Don't worry about making an exact plan . . . these are kids and we aren't meant to control them anyway. They will grow and make their own choices. Instead, this is a dream. What things do you want to see in your eighteen-year-olds? Things like a love for learning, self-confidence, a strong relationship with their families—what will cause these to be so well developed at the age of eighteen?

Dream backward till you get to the age of your child(ren) now. How does your dream for them now fit into your dream for them when they are older? How does schooling fit in? How does learning fit in?

It is also very important to look at other people for examples. What are other families you respect and know doing? No parent has really figured parenting out. We all stumble along on this hugely important task, hoping to do the best we can. Because of this, it is so important that we learn from each other. This is why I am including so many stories of other families in this book. They help us expand our dreams, to "think outside the box" with our kids and their futures. I don't think anyone should copy anyone else, but when we are exposed to different ideas, it helps us expand and develop our own perceptions of the world.

## Your Mission

Now that you have a dream, let's put it to paper. I first got this idea of "A Personal Mission Statement" from Stephen R. Covey in his book *The 7 Habits of Highly Effective People*.[5] I believe in a personal mission statement, but a school mission statement is also very important.

The format and length of this is up to you. You can do a bullet point list or draw a picture. You can have everyone in the family work on it, or compile your ideas alone. Any way you do it, you need to have some of this dreaming recorded and organized on paper.

Beyond the traditional mission statement, I want to encourage you to create some big picture goals for your schooling. I would like you to think about what skills you want your high school graduate to have.

Does this mean you need to homeschool all the way through high school? Not at all! However, wherever your child does get his or her education, you can still be responsible for it. If your child goes back to public or private school at a later time, these big picture goals can help you choose which school. Many of these big picture goals can be worked on during the weekend, evenings, or summer vacation.

So what do you want your high school graduate to know when she is ready to head off to college? What skills do you think she will need? How will you determine your success in homeschooling (or overseeing his or her education)?

If you homeschool part or all of the way, this can't be measured by grades. Every curriculum and school is different, and each teaches different collections of courses at different levels.

From my own experience, I know I can't measure the success of education based on grades because I was a student who always tested well. I could remember words, lists, diagrams, and anything else I needed in short term memory. I was much better at shoving it into my head for a test than I was at truly remembering it for anything useful. On top of that, there is a big difference between knowing the facts and being able to apply them to life. I would much rather my children really master a few key things than strengthen their short-term testing muscles.

It is very easy to just keep reading through this book, but I really want you to grab a notebook and some paper and start jotting some of these ideas down. Go through the questions above and make notes. If you want, you can keep adding to them after you finish the book, but ideas in the head get lost much more quickly than those on paper.

To help you out, here is our homeschool mission statement for an example:

> We, Bryon and Lorilee Lippincott, are homeschooling our children because we believe it is the best for them and our family. We want our children to live in the real world, work with real problems, be constantly challenged, not be overwhelmed, and be supported.
>
> More than specific subjects, we want our children to create a habit of lifelong learning where they are confident and able to learn many new ideas and skills as they go through life. We want them to believe in themselves and their abilities, and to know deep down that they can do anything they would like if they put the work into it.

We want our children to understand different cultures and the world around them. We want them to understand people and know all humanity is equal in value. We hope this knowledge will help them reach and contact people of all economic levels or positions confidently, as well as live a life of compassion while they help others who have not had the same privileges in life.

We want our children to live intentionally, following God and their hearts. We want them to prioritize people over things and character over what society sees as success.

We want our kids to be happy, and we believe this happiness comes from living with purpose and choosing their own way instead of doing what society might tell them is the path to success.

At every point in their childhood, we will strive to provide the education that will help accomplish these goals, whether it be all at home or supplemented with other forms of education.

Because the world is always changing, we have picked some skills we want our children to learn before they leave us and enter the world. We feel these life skills create a foundation for any direction our children will choose to go in life. These are:

1. Different music/composers/instruments/eras/cultures
2. Different art/artists/forms/eras/cultures
3. Different sports and their rules
4. Math, including algebra and geometry
5. Reading well, and enjoying nonfiction reading for learning
6. Complete (but basic) history of the world; all areas of the world in chronological order and how they affected each other as they started to interact

7. Beginning biology, chemistry, and physics so they are prepared to advance in college if they choose
8. Play two instruments well enough to enjoy them
9. Speak two languages well enough to be comfortable communicating
10. Know the Bible—all the books and stories, salvation, and big picture story and prophecy; where we came from, where we are going, and why
11. Be comfortable writing one thousand words a day
12. Proper grammar
13. Ability to speak in public
14. Create and run a business
15. Manners
16. Investment, banking, budgeting, and the evils of debt
17. Housekeeping, laundry, cooking
18. Understanding of different world views—that other people can come to very logical decisions that are different from ours because of the way they see the world
19. Classical literature and poetry
20. Basic computers and an understanding of coding (how it all works)

We believe these areas, when understood at a complete but basic level, will provide our children with a broad and stable base to go any direction they choose.

As much as they are able, we would like the children to be involved in their education. They are not in control of their education because we are still the parents—however, we would like to pass the responsibility over to them slowly so they learn to be self-motivated and feel responsible for their own direction in life.

Most of all we love our kids, we believe in our kids, we want our kids to succeed, and we are so excited to take this journey with them!

## Religious Reasons for Homeschooling

There are many homeschool families who do not homeschool for religious reasons, and this book was not started with a religious intent. However, I homeschool for religious reasons, and a large majority of the families I interviewed also have religious reasons for their choices.

While I won't go into detail in this book, I do want to say that having strong reasons connected to religion, or purpose, are very important to making the choice to start homeschooling and to continue homeschooling. If you feel, like I do, that children are a God-given responsibility to raise and train, you look at your role as a parent and teacher differently. This is the glue that helps when hard days hit. This is the anchor when life blows around lots of different problems or options. This creates the hard and fast "why" that can take us through.

The role of a parent to a child is much like the role of a master to an apprentice or the role of Christ to his disciples. In both the secular and religious circles, we understand this is an effective way of learning.

### Case Study—Heidi

Meet Heidi and her wonderful family of six living in Willamette Valley, Oregon, where nature is everywhere and the world can be their classroom. Heidi had the chance to homeschool during her junior year of high school and loved it. She completed all of her eleventh-grade classes as well as most of her twelfth-grade requirements. She was also able to work in a dental office four afternoons a week. When she returned to traditional school for her senior year, she was bored and felt she was wasting her time. It was then that she determined to homeschool, should children be in her future.

Children were definitely in her future—four of them—and they have been homeschooling since the beginning. Many families are thrown into homeschooling at the last minute, but because of Heidi's experience in high school, she was able to do lots of research even before her first boy was born.

Heidi initially started homeschooling with the vision of promoting learning as a lifestyle, not just as one compartment of life. She wanted to personalize each child's education, promote ownership in them for their learning, focus on rigorous academics, strengthen family relationships, and be able to integrate the subjects for a more practical approach. These ideals have held through the past six years and are why they continue to homeschool.

Heidi and her husband also work specifically on social skills with their children. They want them to be able to interact with strangers, solve conflicts, work as a team, be respectful and kind, know how to be a good friend, take turns, handle disappointment, and follow rules and instructions. They believe that learning these skills requires adequate and consistent coaching by one or more invested adults who know the child well and make a point of providing it. Much of this learning can be learned at home with siblings, but they also socialize outside of the house regularly.

What she didn't realize starting out was how much focus and energy it would take to "keep the show on the road," but she is seeing how her children are growing and developing and is excited to see them challenged. With three active boys who are hands-on learners, she isn't sure they would have enjoyed school as much in a traditional environment. All their abilities and personalities vary, but she can meet them all where he is at without boring him or pushing him ahead before he is ready.

The benefit of being homeschooled as a student and researching it helped her remove preconceived ideas about what school should look like and allowed her time to create her own definition of education. She was able to identify her core "nonnegotiables" and

plug them into the routine and leave the extra hours for reading, talking, exploring, and playing as a family.

## Case Study—Natalie

I have never met Natalie in person, but she still amazes me. Every time I interact with her over email, I sense graciousness and calmness from her. She is a mother I respect and would love to be more like.

Natalie and her husband Joe have been married for twenty years and live in Apple Valley, Minnesota with their nine children—five boys and four girls—who range in age from toddler to late teens. She also runs a home-based business. She learned about homeschooling when she was in high school and after reading about it decided she would homeschool if she had kids in her future. While she was still single, she even helped a pastor's wife for one day a week to "practice" in a homeschooling environment. When she started homeschooling, she was confident and excited about the journey with her kids.

Even with all the planning beforehand, she still says most of her days don't work exactly as planned. But she has been confident in her mission and purpose since the beginning, and even when things don't go as planned, she recognizes these difficulties don't interfere with her big educational purposes.

Natalie has seen her first child graduate from high school through homeschooling (at the age of sixteen) and get into college. She has eight more to go and can now see a better picture of the whole process. Sure, one day may not go as planned, or one month, or sometimes a semester gets interrupted by family challenges, but a homeschool education isn't defined by these short sections. Big goals for kids in both education and character take years to develop.

Some people look at Natalie and say, "Oh, I could never do that." She says it makes her wonder what skills she has that somehow make her more qualified. Natalie believes the only thing needed to homeschool your kids (even if you have nine) is to want to do it

badly enough. If you have the desire, she says, you can not only do it, but do it well.

Natalie's goals are both simple and huge. Here they are in her own words:

"My hope and prayer is that by the time my kids are eighteen, they will be passionately treasuring Jesus Christ, hungry for Truth, lovers of books, thinkers, excellent communicators, humble men and women who put the interests of others first, forgivers, fun-loving, joy-filled, and deeply involved in expanding the Kingdom of Jesus Christ on this Earth. I don't believe I can make that happen, but God can." – Natalie

Natalie has always been very clear on why she homeschools her children and hasn't looked back. This is the power of having a clear homeschooling mission.

4

# Navigating Homeschooling Methods and Curricula

*"I felt that a private, tutorial education, historically used
to train leaders, might have greater benefit to the futures of my
children than a conveyor-belt-type education geared toward
training the masses." – Natalie*

So you are thinking homeschooling might be the right choice for your family. You have a mission statement and a big picture for your school. You might even have the kids excited by the idea. The next question is . . . What am I going to teach?

When I first started teaching my children, I wasn't too worried. If they can tie their shoes, do basic adding and subtracting, write their

letters, and read they are covering the basics of the first few years of school. Not to be too cocky, but I was pretty confident I could explain these concepts and even create some of my own worksheets. How hard is it to teach "2 + 2 = 4" and "A says Ah?"

At first, I didn't think we would be homeschooling long term, so I didn't think much about curriculum. I would just buy a few kindergarten workbooks and create whatever else I needed as I went.

But as we got started and gradually began to realize we wanted to keep homeschooling, I knew I would need help.

Twenty to thirty years ago finding curriculum to use may have been a problem, but the boom in homeschool popularity has blown up the curriculum market. The problem is no longer "Is there anything I can use to help me teach my kids?" but "How do I choose the right curriculum from this overwhelming number of options?"

Because I can't possibly cover all the different curricula, I want to share briefly about some different homeschooling methods. Once you decide on a method, it's easier to choose curriculum to match. But first I want to warn you—there is no right answer, or at least it might take a while to find what seems like the right answer. When I started looking at homeschooling, I looked at many of these methods and liked some and disliked others, but as the years go on, our education and ideas toward education are also changing. You will not ruin your kids if you try many different methods or switch curriculum. Think of methods and different curricula like wall paint (for a project you would tackle yourself). It seems hard to decide at first, but it only takes a day or two and a bit of money if you need to change it later. This isn't marriage, and you are free to change up things every year, or even make changes each month, as you learn what works best for your kids.

Also, please note that many of these methods and curricula overlap, and many companies offer different options. Don't think you have to adopt only one—you can use a combination of methods

in your schooling. A combination of methods is officially called the *eclectic method* of homeschooling and is, by far, the most common.

# Methods of Homeschooling

## Traditional

To start, let's look at the *traditional method*. This is the method most people think of when they think of schooling and learning. It is also called *school-at-home*. Like you might have guessed, this is the method that looks most like a school. This is also the most comfortable method for many new homeschoolers.

Most people who follow the traditional homeschooling method will buy a complete curriculum for the whole year (also called school-in-a-box) that will provide everything they need for teaching. This takes the work out of planning and helps parents who are worried they may miss something in their teaching.

This is also a great method for parents wanting to have an accredited form of education (recognized by another organization as being a complete curriculum). It is debated as to whether this is important for college, but most homeschoolers are not doing accredited curriculum and are not having trouble getting into colleges or getting back into the public school system.

Another plus for this method of curriculum is that it helps with record keeping. Different states and countries have different rules for homeschoolers and how they "prove" their children are learning. If this is a problem or a worry, then traditional homeschooling may be a good choice for you.

The traditional method can come in two ways. It can be textbook based, where students have textbooks and workbooks just like the school you remember as a child, or it can be computer based. There are several curriculums popping up where everything is done on the computer. Computer-based education is very good for a parent who has little time, or does not feel comfortable teaching subjects. It is

also very good for a student to get in the habit of using the computer. However, many parents do not want their children in front of a screen all day and believe this takes away creativity and creates computer addictions.

Often, traditional curriculums are more expensive and purchasing the curriculum for a full school year is a financial barrier for some families.

**Traditional Curriculum:**

- Abeka: www.abekaacademy.org/

Abeka has both a traditional textbook, as well as a computer-based and accredited program.

- Alpha Omega: www.aophomeschooling.com/

Alpha Omega has many different curricula that cover several methods of homeschool. It is listed in this section because it provides full years (school-in-a-box) and also can offer accredited programs. They have both textbook-based and computer-based courses. Abeka and Alpha Omega are both written from the Christian perspective.

## Classical

I have to admit that this method is probably my favorite and has influenced my homeschooling the most. To get the best idea of the *classical method* one should read *The Well-Trained Mind* by Jessie Wise and Susan Wise Bauer.[6] It is a pretty large book, but depending on the age of your child, you might not have to read the whole thing, and it includes tons of great references. With this one book, you can orchestrate your entire child's education from pre-K through high school.

The idea behind classical education is to teach children to learn for themselves. This method breaks down learning into three stages. Children start for the first four years in the grammar stage. Roughly

grades 1–4, these are the years they can take in information the best. These are the heavy, fact-learning years. This stage is followed by the logic stage for the next four years, roughly grades 4–8. These are the years where students can relate information. Where the learning stage brought information in, the logic stage works to help students connect that information together. The final four years, roughly grades 9–12, is the rhetoric stage. In the rhetoric stage, students are encouraged to think and create ideas with the information. It is the output and application stage.

It is explained well in this quote from Susan Wise Bauer's website:

> "Classical education depends on a three-part process of training the mind. The early years of school are spent in absorbing facts, systematically laying the foundations for advanced study. In the middle grades, students learn to think through arguments. In the high school years, they learn to express themselves. This classical pattern is called the *trivium*." —*Susan Wise*[7]

With classical education, there are no specific books or lesson plans to purchase. Instead, there are many different subjects recommended for each year of the child's schooling, and you can piece together curriculum from a variety of sources.

Classical education is more of an ideal view than a specific game plan. However, if you need a game plan, *The Well-Trained Mind* has excellent recommendations.

One thing I really like about classical education is its focus on memorization in the early years, when children are absorbing information the fastest. In our homeschooling, we have made a point of emphasizing memorization in the early years, mostly because it is an excellent exercise for the mind. It is amazing what little minds can learn, and I believe our work with memorization has helped with the other subjects as well.

## Books:

- *The Well-Trained Mind* by Susan Wise Bauer and Jessie Wise
- *First Language Lessons for the Well-Trained Mind* by Jessie Wise and Sara Buffington
- *Story of the World Series* (four-book series) by Susan Wise Bauer
- *Recovering the Lost Tools of Learning* by Douglas Wilson and Marvin Olasky

### Case Study—Stephanie

Let me introduce you to Stephanie. Stephanie and her husband are both entrepreneurs living in beautiful British Columbia. Her husband runs a music school and she works part-time as a writer and blogger while homeschooling their four children.

Both Stephanie and her husband always planned on homeschooling, but she was still a bit scared going into it. Her experience was only in public school, and she wasn't quite sure what homeschooling should look like. Add onto that all the other work of homemaking, cooking, cleaning, and mothering, and it was a bit intimidating.

Stephanie and her family primarily follow the classical model, but as almost everyone interviewed for this book, she mixes in other ideas where she feels it is best for her kids. She likes the classical approach because:

- It works well with how children naturally develop and mature—the learning stages really match development stages.
- Classical education has a very rigorous academic style of learning focused on giving students everything they need to know while teaching them to apply themselves and stay focused on difficult tasks.
- It helps develop self-discipline, hard-work, and strong character.

- The structured approach helps both parents and children stay on task.
- It is also a very strategic approach. It makes sure everything is covered.

Stephanie says her favorite part of homeschooling is being able to be with her kids all day. They are young for such a short time, and it is a privilege to be with them. But on the other side, her least favorite part of homeschooling is also the fact that she is with her children all day. It is hard to stay on top of everything that needs to be done and have so little quiet time. While homeschooling is very rewarding, it is also tiring sometimes.

The more she homeschools, the more she can't envision sending them off somewhere else. Her family is growing closer, the bonds and friendships are deepening, and they want to spend time together. She sees that while she is growing closer to her children and gaining influence in their lives, her other friends who send their kids to school are gradually losing influence and fighting to maintain their relationships with their kids. Stephanie can also begin to see the fruits of their homeschool journey in her kids. They are enjoying learning and spending time reading and listening to books and are always creating—whether it's art or music or stories or building. They are even taking an interest in business as they see their parents work—they want to help with the work, earn money, and learn to save and invest it.

## Charlotte Mason

Charlotte Mason is often referred to as the founder of the modern homeschooling movement. She lived in England from 1842 to 1923. In an age and culture where children were put through strict schooling and punished for not learning long lists of facts, Charlotte Mason wanted to nourish and grow children. She emphasized they were born persons and were not something to fix, but little people with ideas and personalities. She loved children, and her goal was

to build them up. Her ideas revolutionized education in her era and have become very popular for homeschoolers today.

She recommended short lessons using the best literature on the subject instead of modern textbooks or "dumbed down" literature (she called this "twaddle"). Children practice *narration*, or telling back what they have heard and learned. They do this verbally when they are younger and grow into writing as they are able. The focus is always on what children are learning and do know instead of what they don't know.

Like many methods do, Charlotte Mason focused on a broad education, which included the whole person being developed. Children should learn about creating good habits in life, as well as learn and grow academically. She recommended lots of time outside for both education and exploring nature.

Much of what she has taught has been pulled into other more modern methods. What I love about this method is the value and respect given children, and the belief that they can learn well.

## Books:

- *A Charlotte Mason Education* by Catherine Levison
- *For the Children's Sake* by Susan Schaeffer Macaulay
- *Charlotte Mason's Original Homeschool Series* (six-book set) by Charlotte Mason

### Case Study—Bambi

Bambi and her husband are the parents to four sons and four daughters ranging in age from toddler to eighteen years old. Her husband is self-employed in construction, and they live in Texas on twenty acres of leased property with their goats, good books, and family discussions.

Before she was married and had her own children, Bambi was very against homeschooling. Her mother once suggested homeschooling her younger sister, and Bambi accused her mom of trying to make her

sister weird. But all that changed when her first daughter was around three years old. She wasn't ready to send her off to school in a few years, and she didn't want to just "get used to the idea" like other people were telling her she would. She started to research homeschooling on the Internet and slowly became convinced they should be doing it. When they started homeschooling her first child, she didn't know any other homeschoolers, and her husband was skeptical.

Bambi started with a traditional homeschool approach and was shocked at how fast her daughter picked up on the subjects, especially reading. She had anticipated it to be a complicated, tedious, and stressful task, but it was the most wonderful part of her day. Since starting, she has gone to more of a mixed homeschooling method that works best for her family and loves the Charlotte Mason philosophy of education. She has also learned to relax with her schooling and realize that time spent creating, working, and just living can teach a child much more than a workbook can.

When she started homeschooling, Bambi admits, she was doing it for herself. She wanted her children to prove to homeschool critics that homeschooling was the best thing in the world. She wanted them to make her look like a good mom. This produced a very stressful environment for the whole family. However, as time went on, she and her husband revised their mission. They more clearly understood why they were homeschooling and were able to make changes according to their priorities and their children.

Bambi now believes the reason she is homeschooling is to instill discipline in them, to walk alongside them in a gentle and natural way of living, and to teach them the truths of scripture at every turn she can. When she views her homeschooling in this light she is able to evaluate a day's success much more clearly. A successful day to her is when she is able to love her children and teach them more about God. This, she says, is what makes a day successful—the academics are only the wallpaper. What good is beautiful wallpaper in a home if the foundation is crumbling and rotten underneath?

And homeschooling with this mission has been successful in academic areas as well. Her first child, now eighteen, is very thankful for the education she received because it was tailor-made. She could speed up or slow down when she needed to. For the last three years, she has been completely independent in her learning and has taught herself higher math, chemistry, and five years of Latin.

## Montessori

*The Montessori method* was developed by Maria Montessori, an Italian physician and professor who lived from 1870 to 1952. Her methods started spreading in Italy in the early 1900s and now are used throughout the world in public, private, and homeschool education.

The method is described as an "aid to life" and focuses on observing the child to learn his or her needs instead of sticking to a set academic curriculum. It is recognized for independence in learning, defined by helping the children decide what to learn, freedom (within limits), and respect for children naturally becoming the persons they are intended to be.

Montessori classes in school settings have a mix of ages, so it makes it easy to transition to a homeschool situation with siblings. Children are given a choice of several learning options and blocks of time for focused learning and exploring.

The Montessori method is broken down into four planes of development:[8]

1. The First Plane (birth–6 years old): During this plane, the child has an absorbent mind, far more so than at other ages. The child is watching and taking in a large amount of information about its surroundings, as well as language and cultural information.

2. The Second Plane (6–12 years old): During this plane, the child changes physically, relationally becomes much more group-oriented, and developmentally becomes more intellectually independent.

3. The Third Plane (12–18 years old): During this plane, the child is going through puberty and having many more physical changes. Concentration becomes difficult, but creativity flourishes. This is also the plane where the child needs more validation of success from external sources.

4. The Fourth Plane (18–24 years old): Montessori did not do as much writing about this stage, but believed children would further progress in their education and become economically independent during this plane.

While Maria Montessori was alive, she was able to keep tight control over her name and education philosophy, but in 1967, the US patent office declared it not patentable, so now anyone can use the name for their educational methods with or without certification. If you want to follow this method strictly, you need to do your research on how closely curriculum or resources are certified.

## Book:

- *Child of the World: Montessori, Global Education for Age 3–12* by Susan Mayclin Stephenson

## *Waldorf*

*Waldorf education*, also known as *Steiner education*, is similar to Montessori in that it was developed in the early 1900s and is now used in public, private, and homeschool settings. There are Waldorf schools located now in sixty countries.

Rudolf Steiner (1861–1925) was the founder of the Waldorf method and was an Austrian philosopher, social reformer, and an architect. His educational method focuses on three stages of development[9]:

- Stage 1 – imitation
- Stage 2 – imagination
- Stage 3 – truth, discrimination, and judgment

His method pays attention to temperaments, as adapted from the classic four temperaments (melancholic, sanguine, phlegmatic, and choleric) to better teach children. He felt that children will learn differently based on their personalities, and therefore should be taught differently.

In the Waldorf method, students are encouraged to grow and develop in the different stages, resulting in the creation of free, morally responsible students with social competence.

## Book:

- *Waldorf Education: A Family Guide* by Pamela J. Fenner and Mary Beth Rapisardo

### Case Study—Marisa

Marisa and her husband live in North Texas with their four children—three boys and a girl—ranging in ages from six to twelve. Her husband runs a screenprinting business out of their home, and she describes their family as very creative and entrepreneurial. As a child, Marisa really wanted to homeschool but couldn't because her mother had to work. Since then, she always planned on homeschooling her own children.

In the early years of their homeschool, Marisa loved researching educational philosophy, and the first methods she came across were the *Moore Formula* (by Raymond and Dorothy Moore) and Waldorf education. She loved the philosophy of balancing work, service, and interest-based units or projects and wanted to offer her children the highest quality of resources, with rich and engaging literature. The problem was they couldn't afford it. So instead, she investigated ways to homeschool for free.

By piecing together free online printables, unit studies, used curriculum cast-offs, and books, she was able to put together a curriculum she felt was good but ultimately didn't suit the personalities or learning styles of her oldest sons. Their relationship

began to suffer because of that, and she knew something had to change.

She decided to go back to her roots and to the ideas of the Moore Formula and Waldorf, which respect the development of the child and offer a gentler introduction to academics. With these, she simplified down to the ideas that resonated the most with her and discarded the rest. During this time, she was also struggling with health issues and didn't have the energy to execute very complicated lessons. Instead, she built up her home library with good literature.

Marisa explains that the most valuable thing she learned from Waldorf was about temperament. Temperament goes beyond learning styles and gets to the heart of what makes people "tick." She also discovered more about her own temperament, which helped her accept who she was and to be more confident in her homeschooling.

Instead of sticking to a specific school schedule, Marisa and her family try to find predictable home rhythms. Because of her health issues and introverted personality, they do not do many extracurricular activities. She found that when she spent her energies doing these things, there was less left for her kids. They stick to their favorites and what they feel as a family is most important. They also do schooling with seasonal rhythms. In the winter and summer, they do mostly indoor activities because of the weather. This is when they do more creating, reading, and traditional book work. Then in the spring and fall, they spend as much time as possible outside.

Marisa explains she is no longer chasing the rainbow of the perfect method or materials. She can narrow her homsechool values down to three words: *beauty, truth,* and *nature.* For beauty, she exposes them to the most beautiful ideas, art, and culture in the world. For truth, she exposes them to the greatest example of Truth. For nature, they learn to enjoy the created earth and care for it.

## Literature Based

People using the literature-based method of homeschooling are using the ideas from the classical method and the Charlotte Mason method of using literature for teaching children instead of using textbooks. This term is often used when describing several different methods and is very common in homeschooling.

## Self-Learning

In the *self-learning method*, the student chooses what he or she would like to study, and the parent takes on more of a helping role than a guiding role in education.

The self-learning method comes from the idea that if students are simply encouraged to follow their interests, they'll develop naturally in a well-rounded way. It teaches children to be responsible for their own education.

There is not a specific self-learning curriculum, because it lets the student create what will be learned. However, an element of self-learning can easily be added to many other curricula by allowing students to pick and choose books and topics. It is also easy to modify other curriculum timetables and let your student work at a more self-directed pace.

At the end of the last school year, I experimented with this idea by telling my kids how far they needed to get in their textbooks before they could finish school for summer vacation. It was a reasonable amount for them to finish in the time before school finished here (we are currently living in China). But giving them something to work toward, as well as letting them pace themselves, proved both interesting and rewarding. They started the same day we talked, with promises to finish all their schooling that day . . . and they did get a great head start. Their output went up and down as the days went on, but it stayed at a level above what I had been setting as their pace earlier in the year. They practiced setting their own realistic daily goals and learned a bit more self-motivation.

Another interesting thing was how they split up their subjects. Some days, they would do much more of one subject than another. My daughter did almost a whole writing workbook in one day! In the end, they finished school in two weeks instead of the four I had anticipated.

As my kids grow, I plan to use much more self-directed learning in their curricula.

## *Moore*

Raymond and Dorothy Moore are recognized professionals in education around the world and have been very instrumental in the founding of modern homeschool. Their book *The Successful Homeschool Family Handbook*[10] is one of the classics in homeschooling circles.

Their method is similar to many we have covered already in that they stress a simple, nonstressful approach to teaching and learning. They are known for encouraging parents to wait to school their children until they are eight to twelve years old, depending on when they are ready for it. Their research has proven that the time a child starts school does not accurately predict how much the child will achieve academically. Even a child who has a very slow start reading can easily catch up when he is ready.

The Moores believe strongly in a work-study idea of education, where children are involved in manual labor around the house just as much as they are involved in study. They also believe in community service as a method of education.

I have read their book and it is very informative, balanced, and encouraging. Though they do provide a curriculum, their method is one of balance, and these ideas can easily be incorporated into other homeschool methods.

## Resources

- *The Successful Homeschool Family Handbook* by Dorothy and Raymond Moore

- *The Moore Academy* (www.moorefoundation.com) provides curriculum to incorporate their ideals into a more traditional method. It also provides an accredited program with a high school diploma. Their curriculum is not as commonly known as their method, but definitely an option if you want non-traditional schooling with a more traditional plan.

## Thomas Jefferson

*The Thomas Jefferson education method*, also known as the *leadership method*, was not created by Thomas Jefferson but instead uses him as an example. It was created by Oliver DeMille and outlined in his book *A Thomas Jefferson Education*[11]. Oliver DeMille breaks education down into three groups:

1. Public school system: necessary for society, able to help poor families and provide factories with workers
2. Professional education: to create doctors, lawyers, and other professional trades
3. Leadership education: students who will become the leaders in government and be entrepreneurs in businesses; this is what the Thomas Jefferson education is created for

This method stresses a strong literature-based education focusing on the great minds of past leaders and experts in their fields and helps students learn to think like them.

In his book, Oliver DeMille talks about the 7 Keys to Great Teaching,[12] which include:

1. Classics, not textbooks
2. Mentors, not professors
3. Inspire, not require
4. Structure time, not content
5. Quality, not conformity
6. Simplicity, not complexity
7. You, not them

He also breaks learning stages into four different levels that are similar to some of the other methods we have looked at.

## Book:

- A *Thomas Jefferson Education* by Oliver DeMille

### *Case Study—Teri*

Let me introduce you to Teri. Teri and her husband are both self-employed and live in Southern California with their five boys. Back when their first child was born, about twenty-five years ago, very few people were homeschooling or even saw it as an option. However, Teri had friends who had successfully homeschooled. She saw the "end result" in their children and was inspired to follow the same model with her own children.

Teri's specific goal in choosing to educate her children at home was to raise children who knew *how* to think rather than just what to think. Her teaching methods have changed and molded to the ages and needs of her kids, but she really loves the Thomas Jefferson education model because it promotes freedom as the gift that is for all people, celebrates each individual as a unique and possibility-laden creation, and inspires a lifelong love of learning. It is a more natural way of learning and puts the responsibility where it belongs: *on the student.*

She believes that no one can educate another individual. One can merely inspire someone to want to internalize and process what must eventually become his or her own. Because of this, Teri doesn't believe she is teaching material but rather instructing the person. Modern education has become more and more segmented, and it has produced less and less opportunity to mold the person.

With twenty-five years of parenting behind her, all of which she sees as homeschooling years, she isn't sure what a typical homeschooling day really looks like, and she is OK with that. Teri believes education based on grades and getting a job is short-sighted and instead wants

to prepare her children for their vocation or purpose. Her children have responsibilities, tasks, and varied learning opportunities. Copious amounts of reading, discussions, and comparisons are always going on. Her desire is to help her children structure study time and direct them to interests without micromanaging them or their time. Some days it is a lofty goal, but this is what leadership education is about—focusing on the people rather than the content.

She also has the ability to look back and see the success of her journey. Two of her children are now grown and have gotten very good positions that were great fits for them—one with a technology company and one with theater.

Teri believes passion coupled with knowledge often trumps more traditional educational experiences in which comparison and competition are encouraged and wind up producing "sameness" among students.

### Unit Study

*The unit study method* of homeschooling is fun and can easily be combined with other schooling methods. The principle is to choose a concept or topic to study and find ways to tie a variety of subjects to that topic.

We have used unit studies quite often in our homeschooling. About three years ago, we did a unit on Native American Indians. We studied the history and times they lived, the geography of the different tribes, learned about their culture—how they lived, ate, traveled. We learned about several important Native Americans and how they played a role in the beginning of the United States and Canada. The unit study also provided many fun art projects—a TeePee, Native American clothes, and many cooking projects from Native American books. My daughter, who was still quite young, learned to research books in the library about different tribes, and we even branched off and learned about horses—different breeds

and how to care for them, and we took a field trip to see horses. Though our study was on Native Americans, the idea was to provide learning content in many different subject areas.

We were using the *Konos curriculum*, which ties all the unit study topics into character traits. The unit on Native Americans was included in a much bigger unit on "Awareness." As part of the unit, we also studied the five senses, discussed what it is like to be deaf and blind, learned a lot of sign language, and took a field trip to a place that makes braille books. There were many smaller unit studies all tying into the larger concept of awareness.

The beauty and the idea behind the unit study method is that students can learn many different subjects all from one idea and will enjoy and remember the process more. History, art, science, music, cooking, physical education, geography, languages, writing, memorization, and many more specific courses can all combine into a few days (or weeks) of focused digging into one subject.

Unit studies also work very well when teaching several children at different ages. They can all be involved in learning about the topic but, depending on age, some will be able to perform more complex projects or research. It is easier to teach children of different ages all about plants and tailor projects to their ability then to teach one about plants, one about the human body, and one about stars, all at the same time.

Unit studies are easy to create at home with imaginative minds, the library, and the Internet, but it is also easy to find resources online if you search under the term "unit study." Many homeschool blogs provide resources they have created for others to use.

## Other Resources

- Konos curriculum (www.konos.com)
- Or just search for "unit study" or "free unit study" online. There are lots of resources available.

> *"I have wasted a lot of money over the years on curricula and other educational items. I have found that what works best for us is keeping it simple. I sold almost everything and we now do unit studies and real-life stuff. We get almost all our books from the library."*
>
> *–Michelle*

## Case Study—Marcy

Marcy and her husband Tom have been homeschooling their son Ben officially for eight years, but she prefers to believe that homeschooling really begins at birth.

Ben caught on to reading at the age of three and was very talkative and active. Marcy first decided to homeschool him because she was afraid he would be bored in kindergarten, but now sees homeschooling as so much more than just keeping kids entertained—instead it is laying the foundation for their lives.

Marcy struggled off and on with different methods but found that as soon as Ben wasn't having fun, he was acting out. At first, she blamed it on his attitude, laziness, hyperactivity, or her own inability to find a method that would work for his learning style. But then she realized it was just boredom, plain and simple, and most methods did not keep his focus. She explains that Ben is "gifted" with ADHD. She believes God made him perfectly, but keeping him focused and on task day-to-day is hard.

Now she calls her homeschooling method "delight-directed" and is primarily based on unit studies, which seem to click with Ben. They typically do a unit study over a month, and they almost always include notebooking activities and a corresponding field trip.

Their favorite project was when they participated in a geography fair in third grade. Ben was assigned China. He worked hard to learn all he could and build a lovely display that included books, lap books,

a trifold board, games, and food. It was a huge hit, and he still talks about it years later. It even inspired him to want to learn Mandarin.

Ben likes homeschool because of the flexibility. He gets to travel with his dad, take field trips, and do play dates in the middle of the school day. His favorite part is having a say in what he learns. Marcy likes homeschooling because she just loves being with Ben. She loves being there when the lightbulb goes off as he is learning something new and she's having deep discussions with him about things like the Bible and Abraham Lincoln. She loves being able to nurture his passions and strengths, while giving him the time he needs in areas where he struggles.

Marcy plans to homeschool through high school graduation, with plans to knock out his first two years of college in the process. It's common for homeschool students to take community college courses, in person or online, while in high school. However, she is quick to point out that success in homeschooling has more to do with Ben's character than whether he knows his multiplication tables, state capitals, or what year Columbus discovered America. These are good facts to know, but they have little value if they have not laid the foundation for a life of service.

## Unschooling

Unschooling is probably the most different homeschooling method. It also has some of the strongest opinions about it—both for and against.

In its purest sense, *unschooling* is letting the child determine his or her education. If he or she wants to play computer games for a few weeks, this is seen as okay and can be a learning experience. The parent is there to support the child in what he or she wants to learn.

Unschooling and self-directed learning have a lot of overlap in both method and reference. Many people who say they are "unschooling" are doing a great deal of self-directed learning, so the terms may be somewhat confusing. Unschooling can also overlap with unit study.

Because unschooling looks nothing like traditional school, many critics feel it doesn't provide children with the discipline and balance

they need in a successful education. From the outside especially, it can look like the kids are just hanging out all day and not really learning. However, there are many children who have accomplished remarkable things under an unschooling approach. Whether this method can create very motivated kids or it's what works best for highly motivated kids is hard to tell, but just because the idea is different doesn't mean it shouldn't be considered as part or all of your education model.

To be clear, this method does not mean unparenting, only unschooling. The child cannot do whatever he or she wants. He or she still must abide by the family rules. Unschooling just means there is no formal curriculum, set class times, or required subjects. The child just learns by living, exploring, and pursuing whatever interests he or she wishes.

When we first started homeschool, I was very against this method. However, as my children grow, I have been amazed at the projects they have created themselves. I am finding I like giving them as much free time as possible in the day to let them explore and create because I see them learning so much just by playing and being kids.

## Book:

- *The Unschooling Handbook: How to Use the Whole World as Your Child's Classroom* by Mary Griffith
- *Radical Unschooling: A Revolution Has Begun* by Dayna Martin

### *Case Study—Leo*

Leo is well known to many as the author of *Zen Habits* and several other very successful books. However, he is also a committed homeschool dad. He and his wife Eva decided to try homeschooling after being inspired by his sister Kat, who homeschools her kids. Their oldest son was bored in school and getting in trouble for reading in class, and they knew they could do a better job of challenging him and finding things all their kids would be interested in learning.

They also wanted to spend more time with them and be involved in their education.

When they started their homeschool journey, they were living in Guam and there weren't many other homeschooling families around. Also, they faced a lot of concern and resistance from family. On top of that, Leo and Eva were worried about many of the same things most early homeschooling families are worried about—math, socialization, college, and if they were going to screw their kids up.

But that was over five years ago, and they are much more comfortable with homeschooling now. At first, they chose curricula from several different sources but have since changed to unschooling and love it. They have no curriculum and work with the kids to find things they're interested in doing. More and more, they are learning to erase the line between life and "school."

Because they are unschooling, they don't schedule their days. The kids often have projects they are doing on their own. Leo and Eva help their kids with whatever they want to do and spend time reading to them. They also seek out varied experiences and interesting things or ideas to share with their kids to keep their minds active.

Because there are no goals for the day, each day is successful. A great day is one where the kids will play, read, play music, build something colorful, go outside and explore with their parents, or sit down and talk as a family. Their daughter has become brilliant at origami, their son is learning to program an iPhone game, and their younger son is making Harry Potter wands and wants to open his own wand shop.

Leo and Eva love unschooling. They love being with their kids all day, learning with them, seeing them get excited about things, and learning how to play by doing it with them.

## Curriculum Is a Tool

Curriculum is a tool, not a master. These are the most popular methods of homeschooling, but don't feel you have to choose one

and stick with it or even choose one at a time. There are benefits in all of them, and based based on your homeschool mission statement, you might need to combine several methods. Look at your mission statement and big picture goals. Which of these methods most closely aligns with your ideas?

Don't let the idea of so many curriculum options intimidate you. When starting, I don't believe there is a right or wrong method. Do you want to go with the familiar because you're unsure of your role as teacher? Start with a traditional program and work from there. Are you or your child burned-out on school (either public school or a homeschool method you tried before)? Then try a self-learning or unschooling approach for a while and work from there.

Just like parenting doesn't come with proper training and a handbook, neither does homeschooling. Even if you're certified as a schoolteacher, the limitations of a classroom setting and the number of students dictate the way you've been able to teach in the past. Without these limitations, many other methods might work better.

Just like with parenting, set your sights on the end result and do the best you can. When something doesn't get results you need, modify and keep going.

*"I'd often times wished, while I was in high school especially, that I'd had the time to dive deeper into subjects I'd been especially interested in, but there was no time with the structure of the school day, after-school activities, and work! I saw a way to provide this for my child, and that it could not only be a great education, but a much more interesting one, too." – Lindsey*

5

# The Socialization Curse

*"Socialization to me is life, it's church, it's family, social outings, vacations, shopping, serving, sports, and so much more."*

—*Carisa*

After choosing the right method or curriculum, many parents move on to another concern: socialization. We all have seen those children—and adults—who somehow are wandering through life with no social skills, and that's not what we want for our kids. Social skills are a key to both life happiness and success. The fear that homeschooling will leave kids with social disadvantages is why many people don't give homeschool a second thought.

Both my kids are very shy. It makes sense because they are born to two shy parents who didn't have many social skills in elementary school. Both my husband and I were the quiet kids who had a few friends and tried not to get noticed by anyone else.

When we first started homeschooling, my daughter wouldn't go anywhere without me and would never talk to anyone she didn't

know well. She didn't mix with kids her own age and was afraid when other kids wanted to play with her. I was worried that she may need public school to help her overcome her fear.

But I was wrong. My daughter is still shy in some situations but has grown into a different person. In the last five years, we have seen a huge change in her ability to meet people and enjoy new sports or activities with other kids. Whether homeschooling helped or not I will never know, but I do know she didn't need to be part of a traditional classroom to learn these skills.

The best information I received on socialization was from *The Well-Trained Mind*[13] (also mentioned in the previous chapter). The authors point out that school socialization is a very institutionalized and "fake" form of socialization. No one can argue that public school children are learning to socialize in a group of thirty of their peers, but when are these skills going to be needed after school is complete? How many work situations have thirty people of the same age with similar cultural and economic levels working together? *Almost none.*

This idea was like a lightbulb for me. I want my kids to learn to confidently interact with people of all ages, cultures, and economic levels. Before starting our second year of homeschool, the year after our practice year in "basement school," I attended a homeschool information session put on by some homeschool moms in my city. They brought up the idea of socialization with a bit of a laugh. None were worried at all, and what one woman shared really stuck with me. She told about how her son was part of a sports team with several other boys his own age who attended school. One day, the coach came up to her and said, "I can always tell a homeschool kid—they are the only ones who look me in the eye when I am talking to them."

I'm sure there are plenty of public and private school kids who are great interacting with adults, but the coach's observation does bring up an important point. In school, students do most of their talking to other kids, but with homeschool, they are always interacting with adults and kids of different ages. They can regularly meet with other homeschool

families with a broad age of children; they interact with the librarian and store clerks; and they talk to parents and family members.

Socialization is not guaranteed in the homeschool environment, so it's important to be proactive about providing opportunities for your kids to interact with others. If a family is homeschooling primarily to protect their child from the outside world, it is more likely that their kid will be "undersocialized" and will struggle to make friends and feel confident in social situations. But if your goal is less about protecting your child and more about providing diverse and appropriate opportunities for your child to experience the world, homeschooling may be one of the most effective ways to raise a socially adept kid.

Looking back, a personalized approach to socialization was the primary reason we decided to continue our homeschooling. After my daughter had done her kindergarten year in "basement school," she had completed all her kindergarten course work and much of her first-grade year. We didn't work hard at the academics that year, but she was ready and eager to learn and was able to understand many of these early ideas.

At the end of that year, my daughter was finally age ready for kindergarten, but was close to one and a half years ahead in the primary subjects of math and reading. I wanted her to have kids her own age to play with, but I didn't want her bored with school. I knew that socially she was not ready for first grade.

I believe children are ready to learn different concepts at different ages, just like my daughter developed slowly socially but quickly in math and reading. Other kids are very outgoing at a young age, but don't get into reading until later. Often, as kids grow, these abilities begin to even out. It isn't so much that some kids are "gifted" or "struggling," but rather that kids naturally grow in different areas at different paces. Pushing children too fast in areas they are not ready for will overwhelm them, just as not challenging kids when they are ready to learn will leave them bored and possibly jaded.

The best solution for our family was to keep my daughter challenged academically at home and to create lots of social situations outside of our school time. We joined a homeschool group in our city, we found midweek church programs to attend in addition to weekend services, and we made more effort to spend time with other families. She wasn't spending as much time with kids her age as she would have at public school, but she was thriving.

At this stage of my daughter's development, it helped to be able to choose the kids and adults she was socializing with. Some of the groups we tried and some families we played with didn't work as well as others. One of the beauties of homeschooling is that socialization can be adjusted to better fit the child as necessary.

I must say here that I am a fan of sheltering kids. Before you close the book in disgust, hear me out. I believe it is my duty as a parent to shelter my kids. Sheltering has developed a negative connotation, but I see it as my responsibility to protect my kids from harm—not by keeping them shut up in the house, but by being present to monitor whom they're playing with and how they're playing. This is especially true for small children. To be clear, sheltering and controlling a child are two very different things. The first provides safety and guidance in a child's early development years, and the other stunts the child's growth by not allowing him or her to make choices and experience life. I believe in sheltering, not controlling.

When you're with your child, you can help her (as needed) when she is being aggressive or unfair to other kids, and you can help her learn how to appropriately stick up for herself. Parents can also cut any socialization short long before situations arise that would be close to the bullying tragedies we see on the news.

Every situation in life helps create who we will become as adults, and no one can have a perfect childhood, but I believe it is my role as a parent to help my child during these years to grow up safe and healthy. Socialization is a double-edged sword, and I want it to help my child for life instead of leave lasting scars.

## Distractions

I have never taught in an elementary school classroom, but I know that my two children work much better when they are working on individual work in separate rooms. It is way too easy to start giggling, or fighting over erasers, or just watching what the other child is doing instead of focusing on his or her own work.

Instead of mixing academics and socialization, making both less effective, homeschooling lets each side get equal priority and focus in separate spaces. Not identical, but similar in practice, it reminds me of a well-known poem:

> Work
> *Anonymous*
>
> Work while you work, play while you play;
> This is the way to be happy each day.
>
> All that you do, do with your might;
> Things done by halves are never done right.

These are life skills as well. Even though socialization and future employment are interrelated, even in adult life, keeping them separate often makes for better relationships and work performance.

## Some Things Are Just Genetic

I think it is important to add here that many social skills come from genes and how our parents raised us. As I said before, both my husband and I were shy, and we were both raised in school. It's not a big surprise that our kids are also shy, and might continue to have that tendency, no matter how they are educated. There are children who become very different than their parents, but looking around at most families, social skills seemed to be passed from generation to generation.

Often, more eccentric families are the ones who choose to homeschool, and their kids may not seem to "fit in" with other kids.

But is this from their schooling or from their parents? It could be a curse or a blessing, but much of the way children turn out can be traced back to their parents more than their type of schooling.

## Creating Positive Socialization

Both the education and the socialization elements of your homeschool are important and should be planned for. However, just like curriculum, this isn't something to stress about or become overwhelmed by. In fact, much like the self-learning method, many children will create their own socialization. As a parent, we can support, guide, drive, and help organize many of their ideas.

Think back to your mission and big picture. Socialization was probably in there directly or indirectly.

- In what ways is your child currently struggling?
- Where does he need to be challenged?
- How is his current socialization developing his character? His self-worth?
- How is it developing his ideas about the world around him?
- What parts of his socialization "curriculum" (though I hate to make it sound so formal) is working and what parts are not?
- Which activities should be increased and which (if any) should be decreased?

As kids grow, they need more and more control in both the academic and socialization aspects of their education. Where young children might need a lot of sheltering, teenagers probably just need guidance as they get ready to take full responsibility for their decisions when they leave the house.

- Are there gaps in the diversity of your child's socialization?
- Can you create opportunities for them to socialize with kids of different cultures or kids with disabilities?

- What about higher-level professionals who could become mentors?

It is important to me for my kids to feel comfortable socializing with all types of people, so I try to find opportunities for them to practice in a wide range of settings.

### Case Study—Carisa

Carisa and her husband, with their three kids, are inner-city missionaries. Initially homeschooling was not in their plan. Carisa was a public school kindergarten teacher and always planned on sending her children to public school. However, when her oldest son was two years old, they moved to their inner-city mission and the public school situation changed. They started with private school, but eventually decided homeschooling was the best option for their family.

They started using a state cyber school, with Calvert as their curriculum, and loved it. Initially, the adjustment phase of having the kids home all day was tough. That lasted about a year. Now they are much more comfortable in the homeschool routine and are enjoying spending time and working in ministry together.

One of the main reasons they chose to homeschool was scheduling. Since they are missionaries, and Carisa's husband leads the recovery ministry, he has very odd hours. He works evenings but doesn't have to leave home most days until 9 a.m. He also is able to be home from about 3 p.m. to 6 p.m. They didn't want the kids to be gone or doing homework when he was able to be home each day. Homeschooling gives them the freedom to allow the kids to spend as much time as possible not only together but also with their daddy.

Carisa isn't worried at all about socialization. She says the generally accepted ideas about socialization are shallow, and she finds it humorous that people would think proper socialization is putting a group of kids of the same age in a classroom and having

them associate with the same adults (teachers, school staff) all the time. Instead, Carisa explains, socialization is life, it's church, it's family, social outings, vacations, shopping, serving, sports, and much more.

## Case Study—Liz

Meet Liz. She and her husband were high school sweethearts and got married as soon as they finished college. Liz had a degree in elementary education and had goals of being a principal and one day being a superintendent. She wanted to be a career woman who was smart and successful. Because they had significant debts, they never considered being a one-income family.

But all that changed the moment her first baby was laid on her chest. The six weeks of maternity leave flew by, and she was in tears trying to figure out with her husband how she could stay home. At that time, they couldn't make it happen, and they were devastated. However, that period changed their perspectives on the future. They vowed to pay off all their debts, find a better-paying job for her husband, and hold off on more children until she could be a stay-at-home mom. They both worked two jobs, sold their cars, sold their home, and sold every bit of furniture, dishes, and even the sago palms out of their front yard. By the time their first child was eighteen months old, they were debt free! Shortly after this point, her husband got a better job, and she was able to stay home with her son. About one month later, baby number two was on the way. Now they have four—all boys.

Even though she loved staying home with her kids, she was not too keen on homeschooling at first. She had great memories of her own school experience and wanted the same for her kids. Though her husband wanted the kids to be homeschooled, they decided to enroll her son in a prekindergarten for three-year-olds. They could barely afford it, but she wanted to be "normal." All the other kids were going.

It was a disaster. Her son cried every day, she wasn't happy with the instruction he was receiving, and the schedule for getting him there was putting a strain on the family. After trying a few different schools and transferring jobs, she finally started to look at homeschooling.

Liz is still in the beginning years of homeschooling, but she is confident and comfortable with her decision and excited about the journey they are on.

Though she hates to admit it, when she started out, one of her big concerns was socialization. Before she better understood what homeschooling could look like, she was afraid they would all be cooped up in the house all day without any friends. However, now she can say she is not the least worried about socialization. Even if they had not joined classes, co-ops, and playgroups, she is confident in her children's ability to be outstanding citizens, friends, and brothers. Their daily errands and conversations with each other are enough to prepare her children for a variety of situations and people. Now she says, to be totally honest, she would be more worried about the socialization in school.

In her words:

"The opportunity to shelter is a rare thing. It's a good thing. We need to embrace it."

## A Simple Note

We have just gone through two pretty heavy chapters on curriculum and socialization, and you might be feeling overwhelmed and stressed about creating the perfect school for your children.

But homeschooling isn't about curriculum or socialization nearly as much as it is about your child.

I am a perfectionist at heart and always struggle with wanting to modify everything in my life so that it gets better and better. Though there are some benefits to that, most of life is really simple.

In choosing to homeschool your kids, you are making a big decision that shouldn't be taken lightly, but it doesn't need to keep you up all night. Twenty years from now, are you going to look back and regret not picking the best curriculum or are you going to regret not enjoying the time with your kids when they were young? Are you going to regret not setting up more playgroups, or are you going to regret not taking the time to have meaningful conversations with your kids?

Homeschooling is simple and very basic. It's about loving and nurturing a child to become who God has chosen her to be. A large portion of this work we can't control or stop. What we do as parents, while very important, does not guarantee any sort of outcome.

Parenting is less like building a house and more like taking a journey together. Looking at parenting like building a house assumes control, and it assumes completion, where neither of these is healthy or possible. Instead, looking at parenting as a journey with our children where we all are learning and growing can provide the environment for our children to become strong human beings, and at the same time, create lasting family relationships.

Parenting isn't taking on an eighteen-year-long job. Instead, it is being given opportunity, responsibility, and the gift of the journey.

Don't let worry, fear of failure, or the idea that you have failed in some area keep you from trying to homeschool or from continuing to homeschool. When you keep the focus on your kids, things like curriculum and healthy social lives tend to fall into place.

6

# Basic Homeschool Scheduling

*"If real learning has happened, whether or not it had anything to do with math, our day has gone as planned."*

—*Marcy*

There are an infinite number of ways to schedule your homeschool time. Our family follows a more traditional school schedule because it works for us, and most homeschool families we know do also. But before we get there, let me give you some different ideas to get you thinking.

Different states require different things, but if they require specific hours, it is probably around 1080 for the year (which comes out to about 180 days at 6 hours a day, which, if you're doing 5-day weeks, is 36 weeks).

Homeschooling can be done

- in the afternoon and evenings;
- early mornings and evenings;
- anywhere from 3 to 7 days a week;
- primarily on weekends;

- 3 weeks every month, with a week off all year long;
- all summer with several months off in the winter, or all year long with breaks spread throughout the year;
- intensely during certain times and then not at all during holidays or when the parents are particularly busy.

There are probably many more options available depending on your family's needs.

Both my kids enjoy getting up early and are ready to learn as soon as they're awake. Their mother, however, takes a while to get going. Because of this, I often plan their work the night before and set it out for them. While I am wandering around the house dazed or getting breakfast ready, they can start working. Many days they are able to finish most of their book work by early to midmorning, and we spend the rest of the day doing other learning activities.

Our family has also traveled quite a lot in the last few years. The homeschooling schedule has given us the flexibility to take opportunities when they come up and work hard on school when we are home.

But before we get too deep into scheduling, let's talk about what counts as school time.

## How to Add Up School Time

Many parents, including me when I started homeschooling, see school as time spent sitting and working through textbooks. It is easy to see time spent doing math as school time. But, thankfully, textbooks are only the beginning.

Here is a list of other activities that also count as school time:

1. Parents reading to kids: I like reading to my kids after lunch before we all have a rest.
2. Quiet reading: My kids stopped taking naps very early but enjoy reading quietly in the afternoon, as well as early in the morning when they first wake up.
3. Family worship: Worship is educational for religious instruction, reading, logical thinking, art, music, and more.

4. Learning to cook: Cooking can help with math, reading, health, and life skills.

5. Household learning: Household repair and housekeeping are both gold mines for learning.

6. Writing: Both of my kids love writing emails and my daughter has started writing books.

7. Dance, sports, or music lessons: These count for art, music, or PE.

8. Field trips: These can be specially planned for school or a real-life experience turned into a learning opportunity.

9. Library trips: These have probably always been our favorite part of schooling. My kids could spend forever in the library with a stack of books.

10. Gardening: Working in the garden is great for health, PE, and science.

11. Family walk or bike ride: Exercising outdoors counts for PE, health, and science.

12. Shopping: This can be educational if you include the kids in the process of planning, choosing which products to buy, and even budgeting and paying.

13. Self-guided learning: Teach the kids to use online encyclopedias and search tools to find out answers to their constant stream of questions. Just yesterday, my son wanted to learn how marbles were made, so with Dad's help, he found a video detailing the whole process.

So much of normal family life can be a learning experience by just including children in the process and giving them the tools to explore.

I have met very few parents who try to do book work for six-plus hours a day. Though many start this way, they soon realize children are working through their books much faster than expected and benefit from other life-skills types of learning.

Of all the curriculum methods, the traditional and structured methods have the longest times dedicated to book work. This is one reason many families move away from this method as they get more comfortable with homeschooling. Though it is hard to see at first, as you and your children become more comfortable with homeschooling, you start to realize how much learning is done through regular daily activities.

I wrote my big picture goals for my children's education about two years ago and was working with my daughter on her writing. She's nine years old, so I asked her to blog 100 words per day. It was a challenge at first, but soon she was going over 100, so I moved her goal up to 150. That went on for a few months until one day she decided she wanted to write a book.

After her other schoolwork was done one day, she sat down at the computer and started to write her book. I hoped she would get to 300 words, but she finished the following day with 1800 words. Her dad showed her how to draw pictures on the computer, and she illustrated it. Within the week, she had made all the changes and additions I asked her to, included all the illustrations (including the cover), and had it published on Amazon. That was the first book that turned into a series of four books. She has now started a second series of longer books with fewer pictures that are over 3,000 words apiece and will have the third in this series published in the next few weeks.

I expected the goal of writing 1,000 words a day to be something she would perfect in her high school years, but at the age of nine she can easily sit down and write well over 1,000 words a day. The content is still clearly at a nine-year-old level, but her typing and grammar are improving rapidly.

Do the hours she spends creating books in the afternoon and learning how to publish them count as schoolwork? You bet! Do the hours my six-year-old son sits beside her reading over her shoulder laughing uncontrollably at her humorous stories count as schoolwork? You bet!

As I started homeschooling, my worry about getting enough hours in quickly dropped. Thankfully, I am not in a place where I have to keep very strict records, but still, now I never worry about falling short.

When creating a school schedule, I focus on the amount of curriculum and learning I want my children to accomplish and let the hours work out on their own.

## Creating a Home and School Schedule

Unless your state requires very strict record keeping, I much prefer the idea of making a "life schedule" than a schedule specific for schooling. A life schedule allows for the overlap between living and learning. Things like sleeping, eating, socializing, sports, and shopping are all part of life and all affect school. Including them all in a schedule makes following the schedule much easier.

One of the things I love about our schedule is our slower-paced mornings. Instead of being woken up at a specific time, our kids are free to sleep in longer if they need to, which I think is healthy. Where most kids have to get dressed and eat quickly, there isn't a rush to get through breakfast in our homeschool schedule. As I said earlier, my kids often get started on school when they first wake up, sometimes as early as six. Instead of having to get dressed, grab breakfast, and race out the door to get to school, they can wake up when they're rested and focus on schoolwork when their minds are fresh. This also gives me time to prepare something healthy that we can all enjoy together. By the time breakfast is ready, they're ready for a little break from book work. It's a rhythm that feels natural and productive to us.

Depending on the day, the weather, and other life factors, the rest of the day is often organized around meal times and bed times. It can be spent on organized school, self-learning, outdoor exploring, or running around town. Because our life has included a lot of travel

lately, our schedule is constantly shifting, but learning has always been present.

As you create your own homeschool schedule I encourage you to pick specific anchors like:

- specific subjects you want done every day: for us it is math, spelling, and writing;
- set meal times;
- set bed and rest times;
- other fun activities, like reading before a rest time, piano lessons, playgroups, or library times.

These are your anchors for the week. Around these, you can fit in other subjects and child-created projects however you like. This gives you the flexibility for life. Some days, you'll accomplish more than you planned, and it will be exciting. Other days, you'll get sidetracked by someone getting sick, an unexpected field trip, or just life.

Many homeschooling families, including mine, have tried strict weekly schedules because they are traditional and what we were more familiar with. Strict schedules work for some families, but for most they never go as planned. If you are a person okay with "aiming for the stars, but only hitting the moon," then this might work fine for you. But if you can't keep your strict schedule and that makes you frustrated and feel like you are failing, then give yourself permission to adjust your scheduling goals.

Having your child study math at 8:00 and science at 10:00 sounds great, but it is not what determines the success of your home educating. We all feel like we are failing when the dishes aren't done, the laundry is piling up, and the flu has been traveling through the house. Schoolwork gets behind, kids get crabby, and parents lack patience. When life gets crazy, evaluate your homeschooling on your mission statement and big picture goals, including several months or full years instead of individual days. Looking back, you will remember the accomplishments much more than the failures.

## Overload or Soul Fever

As parents, we want to give our kids as many opportunities as we can. We might worry that are kids are not doing enough socially or academically, but the reality is that most of us are much more likely to overschool and overschedule our kids than the opposite.

When I picked up *Simplicity Parenting: Using the Extraordinary Power of Less to Raise Calmer, Happier, and More Secure Kids*[14] two years ago, it changed a lot of my parenting and schooling perspectives. The author names and defines a condition called "soul fever." Soul fever is a sickness caused by emotional overload and it mirrors physical sickness in many ways. Being overworked and overstressed is not healthy for adults, but kids are even less able to cope with a life that is overly busy.

"Soul fever" is caused by overactivity, not enough rest, stress, and too much stimulation and an inability to process or handle it. What the author found was that many kids in developed countries are exhibiting similar symptoms as kids who have gone through very traumatic situations (natural disasters or war), just from a buildup of constant stress. At a certain point, soul fever pushes kids to the point where they begin acting out or behaving strangely.

Parents are usually the ones who can tell that something is wrong—we are good at that, even if we can't put our finger on quite what it is. Kids with soul fever can display very different symptoms: They can be withdrawn or hyperactive. They can be demanding or refuse everything. They can be destructive or controlling . . . the list goes on.

The treatment for soul fever is very similar to the treatment for physical sickness. With physical sickness, we put our kids to bed, cancel all activities, make them special food, cuddle them, and read them books. The treatment for soul fever is the same. Kids need to rest emotionally, heal, and have a chance to think through and process the situation. They need to have some really quiet days with little activity, lots of attention, and maybe even hot soup.

Most parents can tell when their kids have soul fever and are emotionally stressed beyond the processing point. They know something is up; they can tell something is different. But they may not consider the very simple solution of slowing down. Canceling activities and staying home from school is a requirement for kids with physical fevers, but stressed-out kids can continue to be dragged through endless activities with promises, threats, treats, or other "parenting tools" until they have really serious soul fever.

It is possible to take our homeschooling learning goals too far, to try and include too much, to try and squeeze in so many activities we want our kids to benefit from, and end up with a big mess. The benefit and possible danger of homeschooling is that there aren't set hours or a set amount of curricula, which makes it easy for us to go overboard adding things we think are good for our kids.

This is why simplifying our homeschooling with a mission statement and big picture goals is so important. We do lots of things to keep kids physically healthy and safe. We need to take emotional health just as seriously.

A huge benefit of homeschooling is that it is much easier to pull back and take a break. When my kids hit a roadblock in learning—often a new concept that just isn't clicking—they take a break and go lie down for ten or fifteen minutes. It isn't a punishment; it's just a rest to let them calm down and think. They often do this out of habit now, without me saying anything, because they feel much better after a few minutes of quiet.

Around the time I was reading *Simplicity Parenting*, my daughter had been struggling with a new concept in math for a few weeks. She could do it, and understood it, but the mental effort it took her to get through each problem was stressful for her. It was getting near the end of November, and I decided to take the whole week of Thanksgiving off. We hadn't taken a day off school yet during the year, and the public school system had taken several.

During this week, we had nothing planned—no field trips, no outings. The book talked about the importance of unscheduled time, and it seemed like a good opportunity to try it out.

My daughter loved it. She read, colored, and played games, many of which she came up with on her own. She didn't suddenly learn to love math, but she was visibly less stressed. However, my son really benefited academically from the time. At first, he didn't know what to do. This is probably because he is the second child and hasn't had much practice playing alone. But by the second and third day, he was doing better and made a breakthrough on reading. First, he chose a book (by himself) from the library; decided to read it to me (by himself); and read the whole thing (except one word) all by himself. I was so excited! Before that, he had been reading for a few months, and we had been practicing in school, but it was this week that he (several times) chose to read for fun.

Then he woke up Thursday morning and over breakfast decided to count to one hundred for daddy. I was speechless. We hadn't done numbers past about forty with his math yet. He went from one to one hundred straight with no trouble.

Was it our quiet week that helped with these two things? I am sure of it. He had the knowledge in his head, but he needed the quiet and the time to let it settle. Both kids finished the week happier, less stressed, and with a better grasp of their schoolwork.

I struggle with wanting the best for my kids and wanting to push them to greatness. I believe they can do amazing things and both of them perform ahead of their age in school. But I am gradually learning that simplicity and time is even more effective in helping my children than constantly pushing them.

In parenting and preparing our children for adulthood, it is possible for us to forget they are still kids. The idea that kids sit in school for most of the day, five days a week, and then do homework for hours in the evening is a very new concept in society. Children need structure,

and they need to do chores and help around the house, but they are active and creative. They need time to just be kids.

Where the traditional system doesn't have the choice because of standardized tests, culture, and childcare needs, homeschool can give kids this time of childhood back. When I first started homeschooling, I had visions of better preparing them for adulthood, but now I think the greater gift is allowing them to have a real childhood, and it isn't at the expense of their education.

When I was a child, I got sick often and missed school for days or weeks at a time. I would show up to school after I got better and collect all the homework I had missed. To a child, it seemed like a mountain, but it only ever took me a day or two to catch up. Even as a child, I remember thinking it would be more efficient for me to spend my day doing something fun and then do my homework to catch up in much less time than I would have spent in school.

Now that I am a parent I see this with my kids. The amount of book work my children need to do for a day or a week to stay caught up with their grade level isn't nearly enough to fill six hours a day five days a week. Though sometimes they spend longer on certain subjects because they're interested in them or they're procrastinating, if they want to, it's easy for them to finish book work in only a few hours and spend more of the day with hands-on projects, exploring, and just being a kid.

Properly managed homeschool schedules, without overloading kids, can both get them ahead academically and allow them to enjoy childhood. It doesn't get much better than that.

## Schedule Failure

I want to talk about schedule failure.

In August, when everything is fresh and new, we write beautifully crafted schedules. They're filled with a perfect balance of fun,

learning, socialization, and housework, and everyone is excited to get started . . . but then you actually start school.

Everything may run smoothly for a while, but life has a way of not sticking to schedules. Within a few weeks, months, or maybe just days, something will get between you and your beautifully crafted schedule.

All this means is that you are normal and you are trying to homeschool in real life, instead of in a book or in theory. Books, seminars, homeschooling blogs, and curricula work in an ideal world, but none of us live in that world. Schedules are good, but we need to realize they are not always going to work out.

This is a struggle for homeschooling families everywhere. Here are some quotes from other homeschoolers when asked if the school day goes as planned:

"Maybe 50 percent of the time. I wish it were more than that, but life is unpredictable." —Kristen

"I honestly don't think a day has *ever* gone as planned. We get close sometimes. But think about it—in any job, when does a day ever go exactly the way we'd like it to go? We live in a fallen world. The point is not to get our days to go perfectly, but to be available to our Creator in all His divine appointments. Our days are full of those, and it can be a great source of satisfaction and contentment to surrender our days to Him, allowing His purposes and plans to be fulfilled in our lives." —Natalie

"Maybe half the time. A lot of it depends on me and how organized I am and how much I stick to our routine and set the tone for the rest of the family. If I'm tired or distracted or having an off day, chances are that our schooling will get a little off track, too. Other things can also affect what

we accomplish, in both negative and positive ways. If we are dealing with poor behaviors or attitudes, if the baby is teething badly, if someone makes a huge mess, we might not get through everything on our list. On the other hand, if the kids are particularly eager or hardworking, we can sometimes get through *more* than usual. Another option is that we will get to delve into something deeper and possibly not get through exactly what we had planned, but have a wonderful time learning about a particular topic in depth. These types of unplanned days are the best kind.

"How the homeschool[ing] day goes is sort of like our to-do lists. How often do we crawl into bed at night with every item on our list checked off? Not often. And yet, we are continually moving forward, and on the days when we feel as if our day were "interrupted," sometimes it turns out that those interruptions are more important than what we had planned anyway. Having perfect homeschool[ing] days isn't the goal. Seeing success and growth is far more important." —Stephanie

"I have learned that no day goes exactly as planned. This is real life, and being able to adapt is a valuable skill. At least that is what I keep telling myself!" —Heidi

"Very rarely! Because people are unpredictable, it's common for our day to take a turn that I wasn't expecting. Often, I end up spending more time than I'd expected helping one child or another with his or her work. Sometimes, I forget an appointment and have to change my day's plans. (That happens more often than I care to admit.) Occasionally, a friend or relative needs me to baby-sit or help in some other way. And, of course, there's the occasional wonderfully beautiful day, so we scrap school and spend the day outside enjoying the weather! That's how life is. I think it's best for

our children to learn how to deal with those days, because it
will be a skill they will need for the rest
of their lives." —Wendy

"Never, and that's usually a good thing." —Linsey

"Rarely, if ever. Life and relationships are messy. We've learned
we need the ability to adapt and change, because as I've said,
life is full of interruptions and unpredictability." —Teri

"I guess that since my plan is to remain flexible, I can safely
say that every day goes according to plan." —Tabitha

"I have a loose schedule that is never, never, ever followed to a tee."
—Bambi

"If you're asking how often we homeschool between the hours
of 10 a.m. and 2 p.m. and cover all subjects on the assignment
sheet, the answer is probably about half the time. But I don't
necessarily measure the success of our day based on that
criteria. If real learning has happened, whether or not it had
anything to do with math, our day has gone as planned." —
Marcy

"Ha ha ha ha!!! That's a very funny question. Our days rarely
go as planned." —Carisa

"Never. Not once." —Toni

"We'd always start off the year thinking we'd be really
structured and focus on schoolwork from 8 a.m. to 3 p.m.,
Monday through Friday, but as the weeks went on, we'd
realize that was impossible if we were to make time for the
extracurricular activities that mattered to us." —Abigail

"Oh, man, not often! But you know what? It's okay! We
may not diagram the whole page of sentences, but we

have time to engineer Lego planes and aircraft carriers. We might skip a scheduled art project, but we learn about the crayfish the boys run down to the river to catch and release every day. Even the days that don't quite go as planned have immeasurable value." —Danielle

I struggle with feeling guilty when we don't follow our schedule correctly. There are days that go as planned, but there are so many days where something goes awry. I have been learning, slower than I should, that these are not personal failures—they are just part of life. How I react to these situations and days that don't happen as planned is just as important a lesson for my children as their schoolwork.

## Real-Life Scheduling

We need the ideal schedules for the ideal days in homeschooling, and when the day goes as planned, it is exciting for the whole family. But since, as we've discussed, life has a way of getting in the way, I like to work buffer days into our schedule, which I call "real-life" days. We have real-life days the way northern public schools have snow days. What this means is that when we break out our curriculum for the year, we plan on finishing all our books early. I choose curriculum for my children that is low on busy work, which mean they almost always get through their books faster than necessary. So if something unexpected comes up, and we can't get to our books for a day or two, we just take a "real-life" day and don't stress about it.

If you're more concerned about satisfying the minimum number of school hours than you are about finishing the curriculum, keep in mind that all kinds of life experiences can count as schooling.

For example:

- Child gets sick and spends the day reading in bed or watching nature movies. She can't concentrate on doing her book work, but she is still learning.

- Parents are very busy with housework or business. The child can engage in "self-learning," such as reading, art projects, PE, educational movies, or educational computer programs.
- Child or parents need a break. Put the books aside for a few days and work on a bigger science, business, or art project together. Or let the child decide what he wants to learn for the week and have him do a report.
- Company coming. Child can work with housekeeping plans, cooking, and educational board games with friends.
- Last-minute outing invitations. These can turn into an educational field trip or PE.

Even having a school Christmas party with making cookies and watching a movie is something that happens in traditional school, and it can count as a school day at home, too.

It is easy to feel that sticking to a strict schedule every day is very important. Many parents, me included, are self-conscious of our decision to homeschool and want to make sure we do everything exactly right. But sticking to a strict schedule all the time is both difficult and boring—both things we don't want our kids associating with school.

## Other Options to Try

1. Schedule book work for three or four days a week and have other learning activities planned for the other days.
2. Take "book work" break weeks either scheduled or as needed where children do other learning activities and can take a vacation from the books.
3. Offer prizes or school parties for when books are finished, encouraging children to work ahead when they're able to.
4. Pay children for extra schoolwork completed each week. I usually tie my children's allowances into schoolwork and have sometimes paid them for extra projects. This is teaching the

real-life connection between work and money. It is like a part-time job they can take on if they want more spending money.

Our goals as parents are to help our children get in the habit of learning and to love learning. Having school be boring or stressful goes against these goals and is a drain on the whole family. Remember to use curricula and traditional learning methods as a tool and not as a master in your school schedule.

Also remember that kids develop at their own paces and are ready for different things at different times. Students might only get halfway through a year's curriculum because they are struggling and the next year catch up to their age and move ahead.

A huge benefit of homeschooling is this ability to go at the student's pace, so use it to its full potential in your scheduling.

> "Many times how a mom relates to the interruptions is the most important lesson she can teach her children. Much more so than math and science." —Bambi

## Case Study—Mandi

Mandi and her husband were both raised in metropolitan Washington DC, but have chosen to settle their family in rural West Virginia. Here, Mandi works full-time from home, and her husband is a stay-at-home dad with their four daughters and their new baby boy.

Mandi knew she wanted to homeschool her kids from the time she was sixteen. She had a varied education between Montessori, public, private, and homeschooling herself, and she wanted to give her kids a rigorous education with all the joy and wonder Montessori offers.

Though the Montessori method initially inspired them, she says they follow the classical method most closely and mix it with self-directed study and as much unscheduled free time as possible.

Though it seems like these methods are all very different, she likes how it works with her family.

Scheduling has changed for their homeschool as their kids have grown older and they have had more experience. In past years, they would do schooling in chunks with several classes together, breaks in-between, and a very loose schedule. Now, says Mandi, they are focusing more on an independent or self-directed format with their daughters, and school fills much more of the day than it did when her kids were younger.

Mandi has learned that they function as a family better when they schedule and plan less. When she tries to plan, even on a weekly basis, she ends up getting frustrated when things don't go accordingly. Instead, she plans for each quarter, setting goals and looking ahead on projects. Then they go with the flow on the week-to-week and day-to-day bases.

The flexibility of homeschooling has made a big difference in their family. They are able to travel, spend time together, and watch their kids enjoy childhood.

Mandi believes there is value in evaluating her kids' progress through standardized tests, to get a picture of how they measure up to the benchmark, but her actual criteria for measuring success as homeschoolers is more subjective. She tends to measure its success based on how excited her daughters are about learning in general and how they're making connections among various subjects and knowledge. In the end, learning to add two-digit numbers is important, as is curriculum, but homeschooling is more about laying a foundation for them to become lifelong learners. To measure success, she looks for signs that this is happening.

## Case Study—Kelly

Kelly and her husband live in the deep South with their ten children. She describes her husband as practical, steady, and knowing how to do almost anything, and herself as flighty, visionary minded, and

having about "twenty-five great ideas" a day. Kelly loves the idea of simplicity, but her life is always overflowing with several home businesses and lots of little shoes.

When they first got married, they never talked about homeschooling. However, they did discuss the current American way of recreational dating, and both had scars from it they wanted to protect their children from. They were concerned about how they would approach dating and marriage with their children, and were worried that the peer pressure in public schools would hold sway over the relationship values they wanted to instill in their kids. So they hesitantly started researching homeschooling.

At first, she was afraid she would be labeled a "weirdo" or she would ruin her kids, but after a few books and lectures, both she and her husband were sold on the idea. That was more than twelve years ago.

Kelly says they have always used a "hodge podge" of methods. She believes in a "lifestyle of learning," trusting that God has given children the curiosity to learn what they need in a resource-rich environment. They use a "skeleton" curriculum for math and English, and then use lots of literature and unit studies to approach different subjects.

Scheduling is straightforward for her family. There is breakfast, devotions, dressing and chores, family walks, and then the older children do "formal school" while she and one of the older kids helps the younger ones with reading. They take a break for lunch, and then do more reading when lunch is done and cleaned up.

The flexibility of homeschooling has benefited their family a lot. They school year-round so they can take off at unexpected or extended periods of time.

Ask Kelly what she loves about homeschooling and she says it is the freedom of "the world as our classroom," and that each child can follow his or her interests and bents. She loves that learning is

a lifestyle. Her children love the fact there is a seemingly limitless supply of books available and they don't have to sit at a desk all day.

Through their years of homeschooling, Kelly and her husband have come to believe this is the only way to clearly transfer their values, faith, and belief system to their children. They are instructing through life's innumerable lessons and helping them see the world through the lens of God's word. Establishing good family relationships has been paramount in order to build the right trust necessary for that transference.

In Kelly's words: "It's how Jesus made disciples and it's how I think we as parents are called."

7

# Time Management

*"No one can educate another individual. One can merely
inspire someone to want to internalize and process what
must eventually become her own. . . . We believe we are
not teaching material but rather instructing
the person." —Teri*

Closely connected to scheduling is time management. Many
people are used to having their time managed for them by an
employer, and most students are used to having a school schedule
their time. But for a stay-at-home parent and a homeschooled child,
time management is handled on a much more personal level. If
one or both have not had practice managing their own time, it can
become difficult.

If we as parents struggle with getting behind, always talking on the
phone, or spending too much time on Facebook, then our children
will learn these skills. There is also the opposite risk of overscheduling
ourselves and taking on more than we can possibly do.

## My Time Management Back-Story

I struggled with overscheduling a lot before starting to homeschool my children. I could quickly fill my schedule beyond what I had energy and ability for, making me feel overwhelmed, which would lead to watching TV or roaming around Facebook. It was like a ping-pong effect, bouncing back and forth from too busy to totally unproductive. I have monitored my time and schedule more closely since starting to homeschool several years ago, and have made many changes. I still catch myself falling into this pattern occasionally, but I am learning to better schedule my time.

One of the best changes I made to help me better manage my time between me, my kids, and their schooling was to simplify our house. I talk about it in detail in my book *The Simple Living Handbook: Discover the Joys of a Decluttered Life.*[15] About three years ago, I hit a point in my life where I knew I needed to change. I felt guilty because I didn't have time for my husband, time to spend with my kids, time to work on homeschooling, and time to work with the church. I also wanted some time for me. I had my fingers in all these places, but I wasn't happy with what I was accomplishing in any. These were all roles I believed in, and I didn't want them to be competing with each other and end up only half done.

When I analyzed how I spent my time. I realized my house was the area using my time that was least important to me. Having a house, and everything that comes with it, is seen as culturally necessary, but when compared to the time I wanted for relationships, it came second.

This was hard for us to wrap our minds around. As a family, we knew we needed to cut back, but we didn't see how. As a family of four, we felt we needed a 2,000-square-foot house with the garage and the yard and all the other things families fill them up with.

At the same time, we weren't sure we wanted that life. We wanted time for each other, time for our kids and homeschooling, time and money to travel, and room in the budget to help others who weren't as privileged as us. So we decided to start cutting back in our home, bit by bit.

At first, we weren't sure we could cut back enough to live in a smaller place, but the more we decluttered and got rid of things, the more we liked it. I started writing about our progress on my blog, and we started learning about other families who were making the same decisions. Back then, we dreamed of a time when we could only own what we needed to travel and explore with our kids. We weren't sure we could cut back materially or financially enough to get us there, but we loved the idea.

Now, three years later, we have reached that point. We only own what fits in our travel bags and we are currently living in China with our kids. We both work part-time teaching English, we homeschool our kids, and we get to wander and explore the other side of the world.

I share this with you, not because you should sell all your stuff and hop on a plane, but so you understand how much material possessions and the standard house takes from your time. The key to time management is realizing that time is limited—there is no way to get more. If you want more time for your kids, for homeschooling, or for yourself, you need to take it from somewhere else.

Let's look at time management first from the parents' perspective.

## Learning and Maintaining Time Management

The beauty of homeschooling is that it can work for so many different families with so many different schedules. You don't have to be a stay-at-home mom to make it work—I have seen families with alternating schedules pull off two full-time jobs. So the idea of time management will look very different for different people.

However, I wanted to share five tips I have found to help with personal time management.

## 1. Identify the Priorities

There is no way to "make time." If you are too busy, you are too busy. Many people find it helps to make lists of everything that needs to get done. When you have a list, it is easier to stay on task. But, speaking from experience, usually the list doesn't get completed.

I have had success with a tool I got from *The 7 Habits of Highly Effective People*.[16] The author talks about categorizing tasks based on if they are urgent and important. Divide your list of things between four categories: urgent-important, urgent-unimportant, nonurgent-important, and nonurgent-unimportant. Typically, I don't worry about the whole list, I just keep a list of the urgent–important things. This is a list of the most important things I need to do during the day, the things that will make the biggest difference.

This is not a list of everything that needs to get done, and usually it is a short list. Most things I will do during the day are not on the list, but when I put the most important things on the list, I work on them first and find ways of fitting them into my schedule.

Identifying the most important things that need to be done during the day provides the motivation for taking time from other, less-important tasks.

## 2. Identify the Time Wasters and Addictions

I think we all have our time wasters. When we get busy or want to reward ourselves for a job well done, these are the things we fall back on. Common time-wasting addictions include: email, Facebook, Pinterest, blogs, TV shows, books, magazines, or talking on the phone. None of these things are bad things, and we don't need to be productive every second of the day. The problem comes when these things are taking up more time than we realize and being done instead of our most important things (from point #1). None

of these should come in-between more valuable parts of our lives or our relationships.

If you have a problem with one of these areas, make a point to limit it to a specific amount of time, or only when your most important list is finished. Limit the times you turn on the computer or TV during the day, and turn it off when you are done. There are people who have gone on "media fasts" to help them realize and break the addictions. They go back to using them later, but as a tool rather than as a habit.

### 3. Don't Overcommit

How much are you involved in church, the community, school or homeschool groups? How much are you working, and can that time be cut back?

It is hard to say no to these things because they are good things. We can admit a Facebook addiction, but the church or community?

Time is limited, and there are more good things in life than will fit. If you are overcommitted outside the house, it is impossible to take care of the people inside the house. Pick things you are best at, you enjoy the most, or that make the most difference, and find ways of saying no to other things. It is much easier to find more areas to be involved with if you get bored than it is to back out of things because you are overcommitted.

### 4. Cut Out Unnecessary Tasks

Are there things you are doing more often than is really necessary? Can you clean your house less often, do the laundry all on one day instead of scattered throughout the week, or combine running around town in one trip?

Can you hire someone to do certain tasks, like clean the house or take care of the lawn? If you need more time to homeschool, this might be a fair trade. Most people outsource teaching to others, so if you teach your children yourself, it might make sense for you to outsource other areas.

### 5. Grow Yourself

Something I have noticed personally is that I get much more done in life and feel much more effective when I am taking time to grow myself. I love writing and reading nonfiction. Both of these areas energize me and make me more productive in other areas of my life. These are not the "mental break" habits from #2, but rather activities that stretch your talents and your thinking. It may be continuing your own education, working on a new hobby like art or music, or something physical. Take time to do something that is new, challenging, and a little scary, and you may find you have more energy to accomplish your other tasks.

What are you interested in learning? What have you wanted to try but have been scared to? What steps can you take to start growing in this area?

## Teaching Time Management

The best way to teach our children time management is by example. If we are using our time effectively as parents, kids will start to follow our lead. That said, a little extra encouragement can help.

Even in the very early years of our homeschooling, I allowed the kids to have input in creating the school schedule. We learned together what times of the day are the best for the hard subjects, and what times of the day are best for taking breaks. They understood the full school year goals and how they broke down into daily and weekly chunks. We have learned together that our family works much better with loose schedules that can flex around the rest of our life.

Like I mentioned before, I have used allowance as a time management tool in some cases. I don't like the idea of giving children money for nothing, but love the idea of mirroring education to a job that gets wages. We don't take this comparison too far and don't include regular chores, but the idea is that they can make money

for their "work" in the home. If they do their work well, they get a standard "salary." If they want to do extra schoolwork or extra work around the house, they can make more. If they choose not to focus, refuse to do their work, or do it sloppily, they get less pay.

Also, when my kids were younger and going through beginning math books, I could tell they were both catching on quickly. Offering a reward of a party at the end of each book often motivated them to work through the book very quickly. I knew the subject material was something they could handle, but I wanted to make sure they learned each of the steps in order. Often, when they reached a particularly simple concept or got a good night sleep the night before, they would surprise me by working ahead several assignments. This is self-motivation in learning, and I love rewarding and encouraging it.

As students get older, they can begin having even more control over their schedules. Years ago, I worked with a family for a few months helping their sons homeschool in their middle school years. The older son struggled with school and motivation and would have much preferred spending the day outside. So, instead of planning out what he needed to accomplish each day, I wrote out what he needed to accomplish each week. Then he could decide which days to work harder and which days he could spend more time outside.

Good time management takes time to become a habit. Kids need to understand why it's important and see clear rewards for it in their lives. Every child is different in their ability to learn these skills, but for most children, it will be something that needs to be talked through on a regular basis. Verbally helping kids plan, encouraging them to stick with their plans, and praising them for success will go a long way in helping them internalize time management skills.

If it is hard for us as adults to manage our time, it is even harder for kids. But these habits, formed in childhood, will be extremely valuable for them through their lives.

> *"Sometimes the most special moments of homeschooling are the times you are just being together—not meeting a goal or driving to an event. Talking and listening to each other (even a five- and three-year-old) instead of checking off the to-do list."*
> —*Elizabeth*

## Case Study—Heather

I met Heather through her writings on one of my favorite blogs, *The Pioneer Woman*, where she is a contributing writer. Heather and her husband Jeff have three children and live in the Piney Woods of East Texas where Jeff works as a psychologist in the prison system. Heather is self-employed as a writer and web designer. They describe their family as passionate. Their house is full of joyous laughter, singing, dancing, and rambunctious play.

Heather explains they never considered homeschooling as an option until the moment there appeared to be no other option. Their first daughter, Emelie, started school and loved it. Both parents were fully involved in school life by volunteering, attending school performances, and helping her with homework. But at the start of Emelie's second-grade year, she went from being an upbeat and talkative child to turning inward and spending more time in her room and away from family. When the nightmares and bed-wetting started (something that she had long since outgrown), both Heather and Jeff started mentally reviewing every moment she was away from them and every person she came into contact with.

When Emelie begged not to go to school one day, they believed they found the culprit. From prekindergarten through first grade, Emelie loved school and excelled. They followed school protocol by emailing the teacher and requesting a meeting, but were told they would have to wait three weeks before the teacher would have time to speak with them. After another night of screaming nightmares,

they did a quick online search to figure out legal rights and officially withdrew Emelie the following day. Weeks later, in a chance meeting with another parent, Heather learned that Emelie's second-grade teacher was using public shaming as a means to control and discipline her classroom. The woman said Emelie wasn't the first child to be pulled from the class.

Unprepared, overwhelmed, and up to this point being opposed to homeschooling, Heather and her husband had to break the task down into manageable steps. However, within weeks of pulling Emelie out of school, they were acclimated to the homeschool life, and Emelie was back to her normal self.

But that was years ago. They are still homeschooling because they love how it fits with their family.

Now that her three kids are much older, she gives them more control over their schedules, and there really isn't a typical day in their house. It's just as common for Heather to wake up to one child who is up working on her studies at 5:00 a.m., as it is for someone else to be finishing schoolwork while she is preparing dinner. Heather is in the school room and available to answer questions, edit work, etc., but she is more of a resource and support staff at this point in their education than a full-time teacher.

This ability to set their own schedules helps Heather's kids learn about their own work styles. Emelie has learned she is able to do her hardest subjects sometimes as early as 4:30 a.m. when the house is quiet and her mind is clear. Her sister Meredith is the opposite and wakes up in a zombie-like trance much later and does breakfast and chores before she is ready to start her work. Knowing and understanding their preferred work styles will help them as they continue to grow and help them make the most of the times of day they are most productive.

8

# Keeping Costs In Check

*"When people ask me what homeschooling looks like, I often tell them it looks like my boy, lying on top of my dog, reading a book in the sun." —Lee*

Just how expensive is homeschooling? Can my family afford it? How much do I need to spend for my kids to excel?

Based on information from the *Homeschool Progress Report 2009*,[17] students' academic success is tied to the amount of money spent on schooling, but not as much as one might think.

- For homeschooled students where more than $600 per student is spent on education per year, their testing scores average 89 percent.
- For homeschooled students where less than $600 per student is spent on education, their testing scores average 86 percent.

Where the public school average is 50 percent, it is easy to see that, while money is nice, it is not a requirement for a good, homeschooled education.

## Curriculum Costs

Curriculum costs can be as low as $0 if you create your own curriculum, pick pencils up off the street, use the library, or borrow or share homeschooling books with friends. You can also trade skills with friends for music lessons or other subject or classes.

On the other end, homeschooling curriculum could cost up to $2,000 per student or more if you go with an online accredited program, other online courses, and private music or sports lessons.

If you keep the same curriculum and use it with several kids, this can bring the price down.

## Other Financial Considerations

Here are some financial considerations you might or might not have thought of yet:

- Will one parent need to work less to homeschool the children, or is the parent already at home?
- If children do not need to be driven to school every day, can the family live with fewer vehicles?
- Will homeschooling mean you are driving less and thus spending less on gas and wear-and-tear, or will you be driving more for activities and field trips?
- Will fewer school supplies or school clothes be needed because there is less pressure to have everything the other kids have?
- Will food be cheaper because more time can be spent cooking breakfasts and suppers and children won't need expensive, prepackaged lunch items? Less takeout?

- If you are doing extracurricular classes like piano lessons or sports, can you get a cheaper rate if you can do these during daytime hours when most kids have to be in school?
- If your kids are at home and older, can they start a part-time business to make spending money for themselves?

With all these factors and more, the price of homeschooling can vary a lot. Homeschooling, especially if one parent has to cut back on work, is more expensive than public education, but even in the most expensive forms, it is cheaper than most private education.

Keep in mind that there is no entrance fee, required textbook purchases, or required school uniforms for homeschooling. I have never heard of anyone having to pay to register with the state, and no other legal set-up is needed. Everything you pay for in your homeschool is an *extra* that is not *required* for the experience.

I encourage families to start conservatively when spending for homeschool. Many big, fancy programs advertise well and include very good resources, but as you learn more about homeschooling, make more friends, and learn more about the resources in your area, you might be surprised at how much you can get for very little. Especially when children are very young, and the possibility of overloading them is great, sticking to the simple, inexpensive, or free options makes a lot of sense. Use your money for family weekend camping trips or a zoo pass instead of spending for expensive books.

## Homeschooling Money Tips

1. Don't spend a bunch of money on the first set of books or methods you look at. There are so many great curricula and sets of books on the market it is easy to want to try them all. If you have time to research before you start homeschooling, you are at an advantage. If you are thrown into homeschooling or feel like you need more time to research, simply create your own curriculum for a few weeks

or months until you get a better idea of the options and how your child learns. Between what you know, the library, and free online resources your child will not get behind in learning if you put off selecting and purchasing a curriculum for a little while.

2. Make a yearly homeschooling budget based on what your family is comfortable with. This budget will cover books, supplies, extracurricular activities, field trips, and any other school-related costs. The beginning of the school year, when you're buying books and supplies and maybe registering for extracurricular classes, is the most expensive. Our family has set a yearly homeschool budget, and we place money into it every month of the year. Then when schooling costs hit, they never have to affect our monthly budget.

3. If you decide on a specific curriculum, see if you can find the books used. Many cities around the country have homeschooling groups that will do used book fairs or have online pages where you can post if you have things to sell or are looking for specific things to buy. The benefit of the homeschooling culture is that most people are very frugal and helpful. They are willing to share deals when they find them, or pass on resources when they are finished with them. I have purchased many used textbooks off Amazon for much less than the new price.

4. Many people use curriculum for more than one child, but it is also possible to share curriculum between friends or different members of homeschool groups. I have a friend who has two of the Konos curriculum books and I have one. We have traded back and forth as our kids have been ready for different subjects. Also, I have another friend with whom I shared my two math textbooks. This saves everyone money and gives us extra reason to get together and let the kids play.

5. Look for activities with your homeschool group. When we lived in Omaha, our homeschool group negotiated with several performances at the local theater to get a school rate. We saw three or four live performances, including *The Nutcracker* at Christmas, for the price of one student—less than $5. The teacher (me) was free, and children under three were free. Pretty sweet deal for something we could have spent $50+ on if we had gone to public showings.

6. Many music or art teachers will offer a discount for children who can come during the day because it lets them take more students in the evenings. Better yet, see if you can trade off your skills with other parents to teach all the kids different skills.

7. Ask about student and teacher discounts everywhere. Going to a museum, getting a zoo pass, purchasing clothing from a store—I have been amazed at how many places I can get discounts. I have a few pieces of ID in my purse that say I am homeschooling, and many businesses have programs set up. Nothing official, just a card from my homeschool group and my HSLDA[18] membership card. Just a simple "I am a homeschool parent; do you offer any teacher or student discounts?" will work. On a trip we took to a living history museum last fall, we saved over $100 because they gave both me and my husband a teacher discount.

8. Use the "less is more" philosophy when it comes to your homeschool materials. You may not need to buy all the books that are suggested by your curriculum if you live near the library. I have borrowed several textbooks I want to use with my kids, renewed them a few times, and been finished with them before the library requires them back. Do you need a full box of art supplies, or can you let the kids get creative with things you already have at home? Do the kids need a full science kit, or would they do just as well with a magnifying

glass and a few plant and bug identification books borrowed from the library? Learning isn't tied to money, so don't feel you need to run your homeschool like it is.

Most importantly, don't let money be the reason you can't homeschool.

Probably the biggest money issue with homeschooling is whether both parents can work. When children are younger and day care costs are high, it is easier to justify the loss of income to stay home. However, when kids get to school age and public school is free, it makes it harder to justify staying home instead of working.

My family has made changes and sacrifices so we can continue homeschooling. We understand firsthand that it is very hard to make money work with a single income (and that single income for us was self-employment). Over our homeschooling years, we have had to cut back, sometimes drastically it seems, to make money work and still homeschool our kids. But I have never regretted it.

I much prefer to live in a small apartment, teaching and exploring life with my children, than trying to juggle two demanding jobs and struggle with how to handle school pick-ups or sick kids while having a big house. There are things society says are important, like having nice cars and living in a house, that I don't value as much as a happy, stress-free family. My kids will only be young for a few more years, and I will have plenty of time to go back to work full-time after that, but right now I want to make being with them, instead of just providing for them, my priority.

I don't know your financial situation, but I can tell you that homeschooling can be financially feasible for most families depending on how much they are willing to modify their situation and how much they choose to spend on schooling.

If you can figure out how to get one, or a combination of both parents' time, energy, and focus in the schedule for the purpose of teaching the kids, you've sorted out the biggest financial challenge. Beyond that, what you spend on your homeschooling is flexible.

> *"Our oldest daughter went to a private preschool. We quickly realized that private school would get expensive pretty quickly for two. . . . Little did we know we'd end up with five. So, our next step was to try homeschooling. I never thought I would end up loving it like I do. It's not always easy or fun, but I really like planning and learning with my girls."*
>
> —*Georganne*

## Case Study—Linsey

The instant I started reading about Linsey, I felt I could connect with her. Linsey lives with her husband and five kids (with one on the way) on four acres in rural Nebraska. Like me, Linsey never planned on homeschooling and was initially against it from bad experiences with other "veteran" homeschoolers. It took time and research, but in the end, they had to come to the decision themselves for what was right for their family and figure out the best way homeschooling would fit.

Linsey has been homeschooling now for almost ten years. Because she is frugal and has experience homeschooling on a budget, I asked her to write up some tips on how she saves money. Linsey budgets between $100 and $200 per child per year on average for her elementary kids. Here are her tips:

- Use sites like Pinterest to find low-cost and free printables, craft ideas, activities, and more.
- Read classics, then search online for free quizzes or guides to test understanding.
- Check out thrift stores for classic literature. Many people donate them when they are finished, and most shoppers are looking for new bestsellers. You can walk away with armfuls of classics for $.25 to $1 each.
- Library sales! Often even cheaper than thrift stores for classic literature.

- Only buy expensive curricula after you've tried free or used copies and know you'll stick with them. Try to always buy used. Buy new only if you can't find them anywhere else, have other kids to pass them on to, and/or know that they will resell.
- Go straight to the publisher's website when looking for curricula and check to see if they have any sales on books that may have been damaged or missprinted in some way. Many times you can get 30 to 50 percent off retail for some minor imperfections, and the books still include all the pages and be perfectly usable.
- Look for coupon codes for online teaching sites. Renew as you go (month by month), instead of paying for whole years at a time (even if there is an annual discount). Kids outgrow online curriculum or find it doesn't work anymore; you don't want to be stuck with an unused membership.
- Avoid buying every piece of a curriculum. See if you even need a teacher's manual before buying it. (Most parents can figure out the answers to a first- or second-grade workbook without it.)
- Subscribe to sites like SchoolhouseTeachers.com to get access to ebooks and worksheets that you can download and use year after year.
- Look for free classics in Kindle format through Amazon. Use the free Kindle app to read it on your PC, iPhone, or iPad.

Using these tricks could easily save several hundred dollars a year. Keeping your eyes open, talking to other homeschoolers, and doing a bit of research makes homeschooling much more affordable. Don't stress if you can't find all the deals right away. As you go through your journey, you will learn more and more about your area and what you can make use of.

9

# Homeschooling under Special Circumstances

*"We love being with our kids all day, learning with them,*
*seeing them get excited about things, and learning how*
*to play by doing it with them."* —Leo

## Special Kids

Because of the teacher-to-student ratio, it can be very beneficial for kids with disabilities, learning disorders, or gifted children to homeschool. Instead of having a set curriculum, their curriculum can be customized to their specific needs.

Education is most helpful to a child's growth when it is challenging but not overwhelming. Every child is going to learn at a slightly different rate, but the benefit of creating specific curriculum for a specific child is even greater when that child is especially unique.

Some students, depending on their needs, may also benefit from duel enrollment. This is when they attend public school for certain subjects and are homeschooled for the rest. Depending on a child's needs, the child might benefit from having professional help from the school system but homeschooling for a majority of subjects.

## Special Schedules

As mentioned in the chapter on scheduling, one of homeschooling's greatest benefits is the flexibility of scheduling. For some parents, it is hard to homeschool during typical school hours, on typical school days, or for the typical school months. Most states only specify the number of hours or number of days kids must be in school, which leaves a lot of room for flexibility in the year.

Feel free to get creative here depending on what works best for your kids and your family. You may need to change the schedule several times to find what works best at a given period.

## Special Families

Homeschooling becomes trickier in families where there may be only one parent, or where the parents are divorced and are disagreeing on the children's education. But it doesn't mean homeschooling is impossible, even under these circumstances. There are many single parents successfully homeschooling.

I found this wonderful resource specifically for single parent homeschooling while researching for this book. You can find it here at:

http://singleparenthomeschool.christianhomeeducation.org/resources.html

If you are divorced and your ex is not supportive of your choice to homeschool, here are some suggestions to keep in mind:

1. Document everything. Do more documentation than your state (or country) requires to show that your kids are getting

a balanced education. Record as paper documents and also pictures if you can. The more proof the better.

2. Join Home School Legal Defense Association[19] (HSLDA). They are the authority on the legal side of homeschooling and can provide information and assistance if necessary. A divorce or other lawyer may not know all the laws on homeschooling so learning what you can from HSLDA can be very valuable.

3. Enroll your child in organized social or extracurricular activities and make sure it is recorded. If socialization is one of your ex's concerns, this becomes even more important. While homeschool playgroups may work very well for socialization, it may be better to have them join the Boy Scouts or Girl Scouts or organized church groups so that there is clear evidence that your kids are interacting with others on a regular basis.

4. If needed, select a traditional homeschooling model, possibly one that also offers accreditation. This may help give your ex assurance that the kids are getting a "proper" education. After a year or two, he or she might start to see things differently and be more flexible.

5. Consider dual enrollment as a compromise. In this scenario, your child would take some classes at a public or private school and some at home.

Regardless of your family situation, keeping your school mission in mind and focusing on the big picture ideas will help when the day-to-day starts looking more complicated. Find a support group around you, and possibly online as well. Homeschooling is much more common than it was many years ago, and there are probably many other families going through the same challenges you are.

## Case Study—Wendy

Wendy and her husband Scott homeschool their three children in the deep South where they both grew up. Hannah, now eighteen, has autism. She is totally nonverbal and has very poor motor skills. Both Noah (sixteen) and Mary Grace (ten) have ADHD and sensory issues.

Wendy describes their family as "accidental homeschoolers." Hannah was two years old when she was diagnosed with autism and they started checking everywhere for doctors or therapists or educators who could point them in the right direction. Wendy says she wanted to do everything she could while Hannah was still young to give her the best possible chance to learn. Through her research, she found Michelle. Michelle was also the mother of an autistic child and had been trained in a certain kind of therapy. Michelle came to Wendy's house once every three to four months to teach her how to teach Hannah.

After several years of doing Hannah's school program at home, Wendy thought Hannah was ready to try going to school part-time at a local school that had a program for autistic children. For the first couple years, Hannah went for about three hours each morning. Her teacher was wonderful, Hannah loved school, and she was able to use what she had been taught at home. It was beautiful.

But then Hannah's teacher moved away, and the new teacher didn't have confidence in Hannah's abilities. The new teacher set expectations that were very low, and Hannah started to "live down" to them. She was coming home frustrated, unhappy, and bored and even started having behavioral issues she had never had before. After a month of thought and prayer, Wendy made the decision to bring Hannah home, and their homeschooling journey began.

Homeschooling special needs kids has been a lot of work for Wendy, but she is very glad she decided to do it. When she started homeschooling her young child Noah, she had to learn a whole

new way of teaching to match his abilities and focus issues while continuing to work with Hannah. Then, six years later, Mary Grace was added to the homeschool mix and brought with her yet another learning style and her own unique interests and abilities. But through it all, Wendy says one of her favorite things is that she feels like she really knows her kids. She knows what they like and what they don't like. She knows who their friends are. She knows their shortcomings and their strengths. She knows what they know academically and what they need to learn. She knows what upsets them and what makes them happy. She knows who they really are deep down.

10

# True Learning Activities

*"I love seeing my children grasp a concept for the first time. When the lightbulb goes off and you can see that they understand, it's awesome!" —Tabitha*

So much of children's development is connected to having a loving, safe, and supportive environment to explore and discover on their own. Realizing that "less is more" when it comes to educational toys, curricula, and activities can be difficult, but it has proven true in many cases.

More and more people are starting to realize that kids need time to be kids for healthy development. Most parents don't want their kids to dress like teenagers when they're young or start dating before they're ready, but fewer realize that pushing their kids to grow up too quickly academically can be harmful as well.

We are a driven and perfectionistic society that seems to fear getting behind, but some things can't be rushed. I have realized I need to be intentional about creating and protecting space for my kids to be kids. Here are a few ways I do that.

## Unstructured Play

Unstructured play is covered extensively in the book *Simplicity Parenting* by Kim John Payne and Lisa M. Ross[20] and is supported by their research.

For previous generations, free time for play wasn't something parents thought about—it was just what kids did when their chores were done. Now, there is very little free time in most families' schedules. However, the importance of unstructured play is huge in kids' emotional and relational development.

As adults, we realize our need to decompress and relax to deal with all the daily stressors. We often find down time after our children go to bed or before they wake up in the morning, but if our kids are running all day just like we are, they'll never have opportunities to relax.

Unstructured play is when kids get lost in creating something in whatever they are doing. They can be by themselves, with their siblings, or with friends. Adults may be providing occasional props or answering questions, but the kids are creating and executing the activity.

Often deep in imagination, these times are when kids are learning relational skills like teamwork and verbal skills, expanding their creativity, and dreaming. It is commonly believed that before something becomes reality, it needs to be dreamed. We talk about this in business all the time, but we give it fancy names like "brainstorming." Unstructured play gives children a chance to dream, to brainstorm. What is it like being a mommy? A veterinarian? A shopkeeper? . . . Or a tiger?

This is also the time when their education is put to work and takes root in their long-term memories. Examples include:

- Learning to spell words for a sign
- Adding up sales for a pretend store
- Creeping noiselessly through the woods like a giant cat
- Acting out a history lesson
- Organizing a puppet show
- Pretending to be deaf and having to use sign language

These are some examples I have seen my children do in unstructured play, but making a full list for any child would fill much more than a book. This play, though not based in reality, is where kids see the relevance of what they are learning. It becomes a practical tool for them, and they begin to value it. A few hours of playing store, for example, will have a much more lasting educational effect than a stack of practice worksheets. Not only that, it is way more fun for the child and easier for the parent.

When planning our school schedules and picking curricula, I have been careful to select books that are short and to the point. I always hated busy work in school and do not want my kids to have unnecessary repetition. If necessary, I can create more practice on a concept or find other books as needed, but I don't want our schooling to be pressured and pushed by an unnecessary amount of work. I also want to maximize the amount of unstructured time my children have during the day.

## Enemies of Unstructured Play

There are two big enemies of unstructured play that are increasingly popular in society today.

The first is TV and other electronics. I am amazed at the amount of electronics present in children's lives today. Most families don't have just one TV, they have several, which are often turned on whenever people are home . . . and sometimes even when they aren't at home

to entertain pets! Many children have computers in their bedrooms or tablets that they take everywhere with them. Many cars have screens strapped to the back of the seats so each child can watch his or her own movie.

These electronics, which are costing parents a lot of unnecessary money, are stealing time away from unstructured play. Playing before supper, making up stories in the car, turning the living room into a fort Sunday morning, and all the other pockets of time children used to have are being filled with electronic stimulation. And kids quickly become addicted to these electronics, making it even harder for them to play imaginatively when you do turn off the television or take away the iPhone. It is like crack for kids.

It will always be easier to turn on a movie or point children toward an educational iPad app than it is for them to discover their own unstructured play, but it isn't nearly as beneficial.

About two years ago, our family got rid of our TV. We didn't watch it much, it was old and ugly, and I didn't want it in the living room anymore. The kids weren't happy with the idea, but got used to it in time. We still had access to a lot of TV shows and were able to watch educational DVDs on the computer when we wanted. Removing the TV from the house and from sight helped us not to fall into watching things just because we were bored.

If TV and other electronics are stealing unstructured play time in your home, I challenge you to make some changes. Move or get rid of some of the electronics entirely, or put daily limits on them.

Our family purchased the base model Kindle when we started traveling more. It has been wonderful because it holds thousands of books, but won't work for games or other entertainment. They can read many different free or cheap books we can get on Amazon but they can't play on the Internet or use any apps—it is just for reading. It provides us the mobility without the electronic entertainment.

I think there is still room for electronics, movies, apps, and more, but it needs to be scheduled and limited as a family so it best benefits

the child. Children are not usually born able to create these limits themselves.

## Overscheduled Afternoons, Evenings, and Weekends

Extracurricular activities can be wonderful for kids and fun for families, but they come at the cost of enjoying unstructured time.

I read once that a family shouldn't be gone for more than two nights a week. This would include adult meetings, shopping, kids' extracurriculars, and anything else that might get scheduled during weeknights. At first that seemed impossible, but we have tried to stick to this rule and have realized what a positive difference it makes for our family. When one or both parents work, this becomes even more important. Not every night can be a fun night, but they can all be nights spent together and spent at home.

When my daughter turned four, I remember feeling very pressured to get her into more extracurricular activities. It seems that everyone successful in art, or sports, or music can trace back their start to classes or private coaching that started before they were six. When we want our children to be successful, but don't know yet where their interests lie or what they're good at (or if they're good at many things), it's easy to wind up in a scheduling nightmare of constantly racing between classes and activities.

I soon realized that I didn't want that kind of life for my daughter. She will probably never be an Olympian or play professional concerts at the age of twelve, but those things are less important to me than that she grow up to be balanced, creative, and happy. Starting a sport or music and seeing if they are drawn to it at a young age is wonderful, but signing them up for several extracurriculars during the school year and then many camps in the summer isn't beneficial to the kids, the family, or the budget. Sure, it may be fun, but it robs them of the chance for unstructured play and creates a much more stressed family environment.

Stress, even good and fun stress, is still hard for both kids and adults.

Every family is different, so take time to think through what limits you will set for extracurricular activities as well as electronics to give space for unstructured time.

## Exploring Nature

One of the books I read while researching for this book was *Last Child in the Woods: Saving Our Children From Nature-Deficit Disorder* by Richard Louv.[21] The focus of the book is that kids need nature. They need to explore nature, play in mud, keep frogs as pets, and wander off paths. They need to build forts, feel rain, and taste snow. A quote from the book that really got me thinking was:

> "Today, kids are aware of the global threats to the environment—but their physical contact, their intimacy with nature, is fading."
>
> —Richard Louv, *Last Child in the Woods*[22]

Every nature movie teaches kids about endangered animals, global warming, and pollution, but kids don't really know nature on a personal level. It's possible to know about nature scientifically and globally without ever really experiencing it.

It's easy to protect our kids too much when it comes to nature. We tell them to stay on the trail, not to get into poison ivy, not to climb trees lest they fall out and break an arm. But life is dangerous, and shielding our kids too much is not doing them any favors.

I am not saying kids should run free, unsupervised in the woods for hours, like they might have been able to a hundred years ago, but we can help them enjoy the wonders of nature and encourage them to explore.

I once heard a parent reason, "I would rather [the kids] get their thrills and danger from bears when they are little than have to seek it out with drugs later in life." Nature is exciting and full of challenges that kids can experience and learn from.

The book is also quick to point out that nature doesn't have to be "back woods" mountains. Many neighborhoods and city parks offer space to enjoy nature.

Our family loves nature, and we have done our share of walking in bear and rattlesnake country. We have traveled to all but twelve of the states in the United States, and we have camped in many of them. We go on national and state park vacations instead of visiting amusement parks and shopping centers. These are memories I cherish, and I know from the way my kids talk that they will be lasting memories for them as well. As a city kid and a mother, I will admit it often makes me nervous, but I love to explore and want my kids to develop that love as well.

There is something so peaceful and centering about being in nature—the sounds, the smells, the sights, and colors—that changes one's perspective on life and role in the world almost instantly. The experience is vitally important.

With life and habits moving away from nature, it is important to schedule and encourage time for being outdoors. Maybe it is walking as a family to a park close by, camping on the weekends, fishing, or using vacations to go to national parks or rural areas.

## Simplifying Their Space

Back a hundred years ago, it was common for kids to share rooms or just have a bed in the corner. It wasn't common for them to have closets full of toys and clothes. Much of this is not common in other parts of the world, either. But somewhere in the last century in the developed world, it has become the norm for kids to have lots of clothes, toys, and space to fit them all in. Add these material things to schedule overload, and kids have a pretty full and complicated life.

Back when my husband and I realized we needed to simplify our material lives so we could have more time to focus on our priorities, I knew it would also benefit the children. I wasn't sure how much stuff and space they really needed. I was worried that simplifying

their lives too much would leave them feeling neglected or make them upset when they compared themselves to their friends.

But the last few years have taught me a lot about kids and simplicity. When my kids each had their own room, and everything that was needed to fill it, they often had trouble playing in it. Keeping it clean was a constant stress for us all, even with fancy organizational systems and products. Every few weeks, I would go in and do a complete cleaning and organizing for them, which would take me hours, only to have them spend the next few hours of the day undoing the work I had done. It was frustrating as a parent to realize my kids only wanted to play in their room when it was clean, and they couldn't properly clean it for themselves at their young ages. As much as I love my kids, I didn't love the idea of being their maid.

Their clothes were also an issue. I decided to go with shelves in their closets instead of dressers because I wanted to maximize floor space and limit the number of things that could tip over and hurt them. But even though these were cute and organized, the kids couldn't keep it that way. Like most kids, they changed their clothes several times a day and would hunt through and pick out their favorites. Clean, previously folded clothes would always end up in piles on the floor.

Our simplifying cut back their toys and clothes quite a bit, and our first move to downsize our lifestyle was to an apartment where the two kids shared a room. Though they didn't always get along, and the three-year age difference between them posed some challenges, they liked the company of having someone else in the room with them at night.

What I didn't anticipate was how they would pick up the simplifying idea and adapt it into their own lives as they got older. As my husband and I worked at simplifying our lives and we all started enjoying the benefits, the children were learning from our example. Over the last few years, they have done much more

simplifying in their own toys, clothes, and books than I would have ever encouraged them to do.

The result has been much more time and space for them to have unstructured play. They might not have many toys, but they regularly are deeply immersed in acting out imaginary stories, creating forts in the living room, and building sculptures out of the cardboard and bottles waiting to be recycled. They love playing outside and make friends easily with both children and adults.

Simplifying their material lives has allowed them much more unstructured play and removed much of the stress involved in their jobs of maintaining their belongings. There are times they wish they had more of their own space, but they have never said they want to keep more belongings.

With our traveling internationally, we have simplified much more than most people would need to do, but the benefits are still the same. A clean room is much more fun to play in, and maintaining that clean room shouldn't be difficult for parent or child.

## Here Are a Few Guidelines for Simplifying Toys

1. Remove broken or unmatched sets—these are frustrating for kids when they are playing.

2. Remove duplicates—there is no reason for kids to have more than one brand of blocks or different doll sizes. They create problems when the parts aren't interchangeable, and create more clutter in the room without adding more value. If you have similar sets of toys you want to keep, you can rotate the sets and only have one in the room at a time.

3. Remove anything not age-appropriate—toys that are too young or too old for your child are a waste of space in the room.

4. Limit unimaginative toys or toys that use batteries—these toys don't encourage imaginative play and can also lead kids toward more electronic dependence.

5. Limit toys that are tied to specific shows and characters—Cinderella or Spiderman have a specific character and name. They have specific stories and missions. This limits kids' imaginations and can lead to boredom with a toy. Instead, many different generic dress-up clothes or toys encourage imagination to fill in the story.

6. Rotate toys—kids don't need very many toys in their rooms at a time. Each kid, age, and room can contain different amounts, but experiment with different amounts to find out which is easiest to keep clean and encourages the most unstructured, imaginative play.

When in doubt, usually less is better.

There are many other areas where kids' spaces can become more crowded than necessary. Here are some other ideas:

1. Limit clothes in the room to what they need for a week. Depending on how often you do laundry, this is probably plenty. As they wear out, stain, or get lost, you can replace them. No kid needs twenty shirts to decide between or a drawer full of socks. Less decision-making time and less mess means more time and space for doing more important things.

2. Keep dirty laundry in the laundry room or somewhere outside kids' rooms.

3. Limit decorations to the ones they like the most.

4. Change out craft items instead of adding to them. Store craft items in one location so they don't get spread around the whole living space.

5. Use as little furniture in their rooms as possible. They may not need cute end tables, lamps, or bean bag chairs. Somewhere to sleep is important, and they might prefer to sit on their beds than on chairs. If possible, store clothes and toys in a closet that can be shut so they don't take up floor or visual space.

Depending on the age of the kid, his or her interests, and the size of the room, these principles could end up looking very different when applied. This is good. Our kids are very different people who don't fit a specific mold—their rooms don't have to, either. Depending on the age of the children, involve them in the process to help them understand the benefits of a simpler space and creating something that best fits them.

Then use the time you would be cleaning their rooms or nagging them to clean their own rooms to make cookies or play outdoors or find some other way to spend time together.

## An Environment for True Learning

By creating time and space for unstructured play and exploring nature, you are maximizing children's opportunities to grow and develop academically while maturing in their world. Simplifying their space helps reduce stress and distractions, allowing them more energy to focus on greater tasks.

Life happens, things get busy, and rooms become cluttered. The suggestions in this chapter are ideals and not set rules. However, when we see these ideas as valuable and intentionally try to include them in our children's lives, it makes a difference.

> *"When I see Maria pick up a book and read it cover to cover, then I know I am successful!"* —Rhonda

### Case Study—Beth

I want to tell you about my friend Beth. Beth and I have known each other since our kids were babies. She and her husband homeschool in Nebraska and understand the need for playing in nature. They live in a city environment, but close to their home, there is some city property that is not developed yet—this is their playground.

Our kids are close in age and love playing together. Before moving to China, we spent several days traveling to their house (just over an hour away by car) and playing with them for the day. Though officially a day off from school, these were always days filled with learning and adventure—and they almost always included a trip to the "creek" to explore.

One trip last year, as Beth and I sat and watched the kids, I started thinking about the benefits of this playtime together. The most obvious was that they were getting great exercise. They were walking, running, and climbing. But it went much further than that. The weather was just starting to turn warm, and there was still part of the creek that was frozen over. When presented with challenges, the four kids had to work as a team. The oldest naturally started watching out for the youngest in the group and making sure he was safe. One played the scout and checked out different areas of the creek to see where the best place would be to cross.

First they had to figure out how to build a bridge to get across without falling into the freezing water. Lots of ideas and methods were tried until they (fairly) successfully completed the crossing. After that, they decided to try and dam up a narrow part of the creek and learned how hard it was to get running water contained. They learned where they could put a bit of weight on the ice and where they couldn't.

They were deep in their "work" for hours, and the passion and mission on their faces was amazing. Probably most people in the neighborhood don't have any idea the place even exists, but for those hours, it was their whole world.

In the end, the kids were muddy from head to toe, the dam never stopped the water, and my son was soaked from the waist down from falling through the ice. But with a shower and a load of laundry, everything was good as new.

Though we realize how valuable this learning is, it is hard to measure it. And because so much of education is based on

measurements, it is hard to know how to make this fit into a school schedule. However, the more I homeschool, the more I read, and the more I talk to more experienced, homeschool parents, the more I realize these experiences make up some of the most important parts of my children's education. Things like teamwork, quick thinking, analyzing problems, adapting for change, dealing with failure, and project organization aren't things that can be taught from books. These are life skills, but they are also very valuable work skills. In a changing world with more and more college graduates, these are the skills that are sought after and valued most by employers.

## Case Study—Jill

Meet Jill and her husband Andy. Together they have four kids—three boys and one girl—in Menomonie, Wisconsin, about an hour outside of Minneapolis. They live in a small neighborhood along the river on an acre of wooded land. They are super laid-back, peace-loving people who love Jesus.

Jill, like many others, always swore she'd never homeschool. But everything changed when she had kids of her own. When she started homeschooling, she knew nothing about it, everything was a mystery. She read everything she could get her hands on—Raymond Moore, John Taylor Gatto, John Holt—and realized that a lot of good was happening outside school walls. A whole sect of the human race was keeping their kids tucked under their own roofs to learn, and Jill wanted in on the action.

Because Wisconsin homeschooling regulations are relaxed, they have been able to adopt the term "unschooling" to explain what they are up to. To Jill and her family, unschooling means they are free (and happy) to tune into the strengths and passions of each of their four children and then set them loose. They provide lots of different, interesting things for them to explore and focus on what their strengths are as a family.

Jill hasn't always been confident enough to follow her go-with-the-flow philosophy. For a while, she made the kids sit down and do workbooks. Her son, over eight at the time, still wasn't reading, and she was worried. She was worried the whole homeschooling thing might blow up and he might be forever behind in life because she kept him out of school. So they continued plodding through workbooks for a while. It was rough on both of them.

Finally, one day, as he sat struggling through a textbook story about a little girl who wanted a pet (so dry and boring), he turned to her and said, "Can we just read books?" Jill explained that this moment changed everything. She realized she had taken learning out of a real-life context. From that point, they want back to simply enjoying reading together, mostly her doing the reading, until one day he got the spark and took off, completely on his own and without specific instruction. Within months, he was reading to himself for enjoyment for over an hour at a time.

In Jill's words, "This—this!—is what I want for my kids: to discover and learn for themselves, without coercion, so that it will become their own. But, boy, does it ever take faith! I'm learning all the time, too!"

As they continue in their homeschooling, Jill has been more intentional about writing and math, but finds ways to mix it in in as interesting a way possible.

Jill has structured the day with a loose schedule including meals, chores, and a rest time. Chores, she has found, are very important. The kids seem to be gentler and happier with themselves after they've taken part in some meaningful industry. Much of the rest of the time in the day is spent in exploring what they are interested in and playing together.

Homeschooling is making a difference for their family. Jill explains they can see how kind and generous her kids are becoming, how they're learning about Jesus, how their relationships are growing, and how they do so well together in their play. She can see vividly

how their particular gifts are blossoming with all the time they're given, how God's purpose for them is coming to fruition. Jill started homeschooling because she didn't want her kids to soak in all they saw public school kids absorbing. But now they homeschool because they feel it's the best thing they've done with their lives to this point (besides having the kids in the first place).

## 11

# When You Want to Quit

*"We continue to homeschool because it becomes more and more obvious how this one choice nurtured our kids and family as a whole." —Heather*

For many families, the question isn't whether they think homeschooling is right for their children, and if they are honest with themselves, they know they could afford to do it as well. The problem is, they are afraid.

Maybe families have started homeschooling and become overwhelmed, maybe even given up at some point when it wasn't working out.

Homeschooling, like parenting, is not always easy. It never works the way it sounds in a book, and patience is lost even after using all the tricks and tips. The difference is that parenting isn't optional (or shouldn't be considered optional), but homeschooling is. In fact, many people might have others in their lives who encourage them to give up and send their kids back to school.

I don't want to say anything against other forms of schooling or against families who choose them, but I do want to provide encouragement to families who feel deep in their hearts they should be homeschooling but are discouraged.

When we started, we worked on a mission statement and big picture goals. These are a lifeline when difficulties hit. What will help achieve the goals set out in the mission statement? If it is another form of schooling, then making this change would be the right choice, but if there is progress at home, and a form of homeschooling will still work best, it is worth sticking to it. Even though homeschooling can be a challenge, it can be something used to make a family stronger and closer together—challenges often do that.

There are three areas I want to talk about that I have struggled with and seen other parents struggle with as well: burnout, lack of confidence, and guilt.

## Burnout

I don't think anyone has tried homeschooling without feeling burnout. Some probably feel burnout just by trying to decide on a curriculum or by researching methods. They read some books, and their excitement quickly turns to feeling overwhelmed.

For others, burnout hits a few days, weeks, or months into the homeschooling process, when school books aren't new anymore, and the excitement of schedule gets old. Or when the good activity and field trip ideas start to run dry. Or when kids would rather sleep in, fight with a sibling, or keep sharpening their pencils all through the math lesson time. When the excitement turns into work, and the work becomes monotonous.

It is important to realize that burnout happens to every family, to different degrees, probably many times during their homeschooling. Burnout happens to families who are sending their kids to traditional schools, as well. Burnout happens with jobs, with volunteer commitments, with housekeeping, and even with parenting. Burnout

doesn't mean there is anything wrong with you, your kids, or how you homeschool. It is just a natural part of life.

The benefit of homeschooling is that it is much more flexible than other areas of life, and this flexibility makes it easier to deal with periods of burnout.

The two most common ways of dealing with burnout are to take a break from the task or change something within the task. While we can't do that very well with a job, both of these are very easy to do in homeschooling.

## Taking a Break

As mentioned in the chapter on scheduling, it is perfectly okay to take a break from schooling. If it helps you rationalize it, you can call it a snow day, or a teacher training day, or take a half day for a "parent-teacher conference," where the kids go to grandma's and you head out with your spouse.

You could pack a picnic and head to the zoo, beach, or park for the day. The kids will still learn a lot from their surroundings, and the change of location and schedule will give everyone a break. Better yet, find a way to get away for a few days by going camping or visiting family or friends. Creating a mini-vacation, even in the middle of the week, with family or other homeschooling kids is a great way to take a break.

When we lived in Nebraska, we were really close to a great zoo. When we needed to get away and take a break, we could spend the day looking at the animals or watching one of the educational IMAX shows. The kids still learned a lot, but the day was a mini-vacation for all of us.

We also had friends (Beth and her family from chapter 10) who lived just over an hour away who also homeschooled. We would schedule "break" days to go down and see them and do educational activities, or just let the kids play while we talked. The projects the

four of them came up with will be memories my kids will always hold of our homeschooling years.

You can intentionally plan breaks into your school schedule to try and avoid burnout, or you can keep some "wild card" days. You can keep your days off education related and have them still count as school days, or you might want to just forget about school and add the days in at the end of the year. Many times, I wanted to just get away from school completely, but then I found we were still doing educational things (even if it was just a lot of PE or cooking), and so I didn't worry about adding the days later. What kind of records your state (or country) requires might affect how you choose to do it, but taking breaks is important for the whole family.

## Changing Something

The other way to deal with burnout is by changing something in your homeschooling. You could switch up your daily schedule, find different books, or evaluate the homeschooling method you are using. Do you want more control over planning the day's curriculum? Do the children? Or do you want more figured out for you that you can just follow? The vast majority of homeschooling families use a combination of several methods that continue to grow and change as their kids and situation need. You can make the commitment to teach your kids at home, but beyond that, you really don't have to commit to anything else specific. Buying a new textbook or changing activities may cost money, but if you can afford it, and it will keep you homeschooling happy, it is worth it.

I have found changing the schedule of our days helps us all with burnout. Also, changing the location of where the kids are working often helps their focus and provides a sense of newness.

My kids like changing or adding extra "classes." We can schedule a cooking class in the afternoon, or a soccer class, or they may decide to work on a unit study project. With the new elements being added

to the end of the day, even the beginning of the day feels new and different.

## Burnout Is Serious

Burnout isn't about weak parents or unfocused children. It isn't something to push aside or try to ignore. Instead, it is good to anticipate it, recognize it, and take steps to minimize it. It is a reason many families quit homeschooling, and it needs to be seen as the danger it is. Letting it bottle up and get bigger will only make everyone frustrated with each other, education, and the whole homeschooling process.

## Lack of Confidence

Another reason parents become overwhelmed and want to give up on homeschooling is lack of confidence. They may feel insecure in their teaching abilities or in their parenting abilities, or both.

Because schools are regulated and tests are standardized, they become concrete measures of success. Teachers have teaching degrees, textbooks are approved by a group of presumably experienced people, and grades give tangible evidence of where kids stand compared to their peers. When you send your child to a traditional school setting, there are a series of checks and balances that are there to ensure they are getting a good, well-rounded, education. At home, there is just you and your spouse.

But looking at it this way isn't the full picture. True learning can't be concretely measured by standardized tests, and no one knows your child better than you. A school system might say your child is behind or ahead academically, but you will have a much better picture based on the time you spend with him or her. The goals you have for your child are probably different than the goals a random school principal or teacher would have for your child. Traditional education will measure based on its goals—depending on the school,

those goals are probably centered around good test scores. If your goals are more about fostering positive character traits, curiosity, faith, etc., then does it matter whether or not your child measures up to his or her traditionally schooled peers? Worrying about that is like planning a trip from point A to point B and worrying if you are getting closer to point C. If that isn't your destination, why are you so anxious about getting there?

I am not saying to rule out standardized tests or that a series of checks and balances doesn't benefit students. Balanced academic success is a goal for homeschooled students and should be highly valued. Regularly, go over your big picture educational goals as a family and find ways to measure how you are working toward them. If you want to do standardized testing, talk to your local public school or look up the tests online. Just remember that your child is a whole person, not merely a test score, and don't let any one measure define your homeschooling success.

As students get older, it is easy to lose confidence in the ability to teach some of the more advanced subjects. Deal with these specific subjects for what they are, and don't let it define your ability or confidence in the entirety of your homeschool experience. You could choose an online course in the subjects you're concerned about, enroll the child part-time in a local school, or hire a tutor. Many cities have homeschooling co-ops where parents trade off teaching the subjects in which they're more confident.

Define your own checks and balances for your homeschooling. Let your spouse and other family and friends who you trust weigh in on your child's progress and try to listen with an open mind. You don't have to act on anyone else's advice, but at least see what you can learn from it. For inspiration and guidance, talk to other homeschooling families, as well as families with children in traditional school settings. Some states require that kids either take standardized tests or hire an evaluator (who meets certain requirements) to meet with you and

your child and review his or her work to make sure you're meeting state educational standards. Even if not a formal requirement for your state, you might find either of these methods reassuring.

It is easy to let lack of confidence in one area build until it overshadows your whole homeschooling experience. Don't let it. Assess if it is really an issue by talking to others, or possibly using standardized tests or external measuring. Then, if you need to supplement for specific things, take the steps to do it. Just because you are taking full responsibility for their education and training them at home doesn't mean you need to know everything or even understand how to do all their work. All you need to do is keep them going in the right direction and make sure their questions are answered correctly.

## Guilt

I struggle a lot with guilt. It can come from many angles, but it often affects how I feel about my homeschooling. Reasons to feel guilty are everywhere and are especially strong when connected to our children. It is one thing if we fail at a job or a business plan, but if we fail when raising our kids, it is a much bigger deal.

If you have positive memories of a traditional education, you may feel badly that your kids are missing out on that experience. Taking them out of the traditional schooling environment can mean they won't have the same school memories, but it doesn't mean they won't have their own great school memories.

Memories are created in homeschooling through exciting projects, through great field trips, through family trips, and through group activities with other kids the same way they are created in traditional schooling. If you're worried your kids are not building happy school memories, work on doing something memorable with them in the near future. Maybe you can create experiences for your kids that are similar to the ones you cherish from your education. Can you

plan a science fair with other homeschoolers? A school dance? Can you form a soccer team? It is possible to have many social memories and strong childhood bonds outside of the traditional school setting. Plus, you have the added benefit of being better able to monitor their social relationships and development than if they were attending traditional school.

Guilt can also come from a perceived failure in homeschooling schedules or parenting. When the grand ideas for education don't work out in real life, when our patience runs out long before the day runs out, when burnout starts to hit, and when everyone's hungry and dinner isn't on the table, it is easy to feel like we are failing our kids. But that isn't what it means at all. We are just living in real life, with real kids. We can strive for perfection in ourselves and our homeschool experiences, but we can't expect it. Most of us don't demand perfection from others, and it's unfair to expect it from ourselves.

The best way to deal with guilt is with action. I believe in being honest with kids about areas in which we have weaknesses. I have spent several mornings with my kids apologizing for what happened the day before. They know I'm not perfect, but I want them to know that I am okay with admitting it to them. I want them to know it is okay to make mistakes and that they are a part of life. So first, I apologize. Second, I work to fix the problem, to make the next day better.

Guilt without action is useless, but a bit of guilt when used for positive change can be good. It would be wrong to go through life thinking we are perfect. Use your guilt and insecurities to make your homeschool, parenting, and lives better.

"A great day is when no one cries, throws pencils, locks herself in the bathroom, or threatens to run away. Okay, so that's just me. No, really. A great day is not just getting all our stuff

ticked off the schedule. It's when everyone has enjoyed our time together, had one or two 'lightbulb' moments, planned an upcoming project or trip, and laughed about some memory. Homeschool is just doing life together, with a few extra books thrown in." —Georganne

12

# The Legal Side

This all may sound nice, but many wonder if homeschooling is really legal? What makes it legal? When did it become legal? Can someone come and take my kids if I don't follow the rules? Will it stay legal?

The short answer would be, "Yes," homeschooling is legal in all fifty states of the United States. Each state has specific requirements. Homeschooling has only been legal in all fifty states since 1993.[23] No one can take your kids if you are following the law. No one knows how long it will stay legal, but lots of work is being done to ensure it will.

Because education in America is handled on the state level, there are a lot of differences between each state.

## What Can I Do to Make My Homeschool Legal?

In most states, there are requirements you have to meet to be considered legal, and if you don't comply with those requirements, you are breaking the law on mandatory school attendance for school-aged children.

That being said, it's generally pretty easy to properly comply with the requirements. Home School Legal Defence Association (HSLDA) breaks down state requirements into four sections:[24]

1. States that require no notice: no state requirement for parents to initiate any contact.
2. States with low regulation: state requires parental notification only.
3. States with moderate regulation: states require parents to send notification, test scores, and/or professional evaluation of student progress.
4. States with high regulation: state requires parents to send notification or achievement test scores and/or professional evaluation, plus other requirements.

A complete list of how each state ranks is on its website at www.hslda.org/laws/.

Finding out the requirements for your state and following them is the first step to starting your homeschool. Check with your state's government education page for information. You can also find most information on the HSLDA.org website and with homeschool groups in your area. With around two million children homeschooling in the United States, you probably have a homeschool group close by.

## The Incredible Value of HSLDA

I am a member of HSLDA and strongly recommend it to any family considering homeschooling. The association started in 1983 and works as a legal advocacy organization established to defend and advance the constitutional right of parents to direct the education of their children and protect family freedom. Tens of thousands of families are members.[25]

My membership with HSLDA keeps me informed about laws, lets me support lawyers who are fighting for the freedom to

educate at home, and provides me with legal help if I need it in my homeschooling journey.

I have never run into any homeschooling legal troubles. However, in cases where local officials don't understand the laws or where legal requirements haven't been fully understood or followed, having HSLDA is an amazing resource.

## Parental Rights Amendment to the Constitution

Will homeschooling stay legal? I hope so. Right now, there is a group of people fighting for the Parental Rights Amendment to be added to the constitution, which would help protect some of homeschoolers' rights. I asked Michael Ramey at www.ParentalRights.org to share with you more about the "front lines" of homeschooling.

1. What is the Parental Rights Amendment?

The Parental Rights Amendment includes many parts. To summarize, here is the short description of each part:

> **Section One.** The liberty of parents to direct the upbringing, education, and care of their children is a fundamental right.

> **Section Two.** Neither the United States nor any state shall infringe [on] this right without demonstrating that its governmental interest as applied to the person is of the highest order and not otherwise served.

> **Section Three.** The parental right to direct education includes the right to choose public, private, religious, or home schools, and the right to make reasonable choices within public schools for one's own child.

> **Section Four.** This article shall not be construed to apply to a parental action or decision that would end life.

> **Section Five.** No treaty may be adopted nor shall any source of international law be employed to supersede, modify, interpret, or apply to the rights guaranteed by this article.

2. Why is the amendment needed?

The status of parental rights in American courts was thrown into confusion by the Supreme Court's ruling in *Troxel v. Granville*, 530 US 57 (2000). In that case's splintered opinion, most of the justices held (though there was no one majority opinion) that parental rights are a "fundamental right," but only Justice Thomas held that they should be accorded the same "strict judicial scrutiny" provided to other fundamental rights. As a result, lower courts since have had to chart their own paths—which vary widely from one to another—regarding parental rights.

The US District Court for the Western District of Virginia perhaps put it best in 2008 when they opined that "the precise confines of the right to familial privacy are nebulous," and that "there is little, if any, guidance from the relevant case law that would permit us to chart with certainty the amorphous boundaries between the Scylla of familial privacy and the Charybdis of legitimate government interests." (*Proctor v. Greene*, 2008 WL 2074069, 5 (W.D. Va. 2008).)

Meanwhile, the rise of United Nations "human rights conventions," such as the Convention on the Rights of the Child and the Convention on the Rights of Persons with Disabilities, pose challenges in international law. Both of these conventions contain language that would replace traditional parental rights with an obligation on the part of the federal government to be the ultimate authority on what is in "the best interests" of every child. The legal presumption of parental fitness would be replaced by a bureaucratic quagmire.

Only an amendment to the US Constitution can address and correct both of these issues—domestic and international.

3. Who wrote it and who is working on getting it approved?

The principal author of the Parental Rights Amendment is Michael Farris, JD, LLM. Mr. Farris has more than thirty-five years of

litigation experience as a constitutional lawyer and has argued cases before the US Supreme Court (and other state and federal courts). He is the Chancellor of Patrick Henry College, the Chairman of the Homeschool Legal Defense Association, and the President of www.ParentalRights.org.

While Parental Rights works with many allied organizations to preserve parental rights in various ways, it is the primary national organization working with grassroots efforts to support the Parental Rights Amendment.

### 4. What will it change if it gets added to the Constitution?

If passed, the PRA will remove the confusion in the courts, establishing instead a clear level of legal protection for fit parents in all fifty states. It will also remove the threat that international conventions could be adopted by the Senate that would override parental rights. The clear standard it provides will hopefully make it easier for state actors to recognize and not abuse the rights of parents, even when parents make a decision with which the state's workers do not agree.

The government's interest (that is, legal authority) to protect children from abuse and neglect, however, will not change.

### 5. What will happen if it doesn't get added?

Without this amendment, the right of parents to direct the upbringing of their children will continue to be at risk from bad court decisions and from international law. In the worst-case scenario, parental rights would continue to erode at the federal court level and strict scrutiny protection would be completely stripped away. State courts would follow these federal precedents, and soon parents would only have the rights that a judge chooses to grant them—which are no rights at all. A treaty could be ratified to transfer authority over our children to the federal government, and parents could become

nothing more than government agents in the raising of children. A generation later, everyone would have been raised according to strict government dictates, and all freedom would have been lost.

6. How often is the Constitution amended?

There is no time restriction on how frequently it can be amended. Since its adoption in 1787, twenty-seven amendments have been added to the Constitution. The first ten of these—the Bill of Rights— were adopted together in 1791. Since then, the Constitution has been amended only seventeen times.

7. What is the United Nations' Convention on the Rights of the Child?

In recent years, two United Nations human rights treaties have threatened American parental rights: the Convention on the Rights of the Child and the Convention on the Rights of Persons with Disabilities. Each of these treaties, if ratified by the United States, would override American state law on parents and children, and give the federal government a grossly expanded decision-making role in the raising of children. Each of these treaties would establish, "In all actions concerning children (or children with disabilities), the best interests of the child shall be a primary consideration." Adopting this standard, however, would "provid[e] decisions and policy makers with the authority to substitute their own decisions for either the child's or the parents', providing it is based on considerations of the best interests of the child." (Gereldine Van Bueren, *International Rights of the Child, Section D*, University of London, 36 (2006).)

In short, the adoption of either treaty by the United States would remove the legal presumption that fit parents already act in the best interests of their children, and that the government should not interfere in parental decisions absent a showing of abuse or neglect.

8. Is this just a homeschooling issue? How does it affect families who aren't homeschooling?

Parental rights shape every family, regardless of their educational, political, religious, or philosophical views. The right of parents to pass on their beliefs and heritage to their children is a vital part of America's vast diversity and strength. If these rights disappear, every other battle for American liberty will be lost. If children can only learn what the government would have taught, only believe what the government will allow, and only think as the government would have them think, there will be no one left a generation from now to take a stand on any other issue.

9. How can I find out more about the current status of the amendment?

The quickest way to get an update on the status of the amendment is to visit www.ParentalRights.org.

10. How can I help?

Two primary ways anyone can help are: (1) get plugged in, and (2) spread the word. Concerned Americans can get plugged in by signing up for email updates at www.ParentalRights.org. Those who do will be notified when calls are needed to Congress to support the amendment, to the Senate to oppose these UN treaties, and so on.

But as of this writing, so few are even aware that parental rights are at risk. This is why it is so important that those who learn about this issue then spread the word to their friends and family. Only by working together can we push Congress to complete their task of proposing the Parental Rights Amendment to the states for ratification.

# Homeschool Encouragement

Before we get to the end, I wanted to include encouragement from other homeschool families. We have a lot we can learn from each other, but much of what we need is support. All these quotes are from families also homeschooling who want to encourage others to try it.

Place a bookmark on this page. If you get discouraged or overwhelmed in your homeschooling journey, pull the book back out and take a look again. *You can do this*!

"Trust in your kids. They are bright and capable. Put opportunity at their feet and watch them jump in." —Nancy

"Try not to worry or be afraid. There are a lot of homeschool graduates out there who are doing well in college, in the workplace, and in their neighborhoods. Homeschooling can work just as well as or better than public schooling, so don't be worried about that." —Kristen

"One day at a time. God gives grace only for *now*. When you start out, all you need to worry about is reading wonderful books to your child, teaching them the ABCs and 123s, and exploring the world together. As they get older, so do you, and

you will know then what the next step ought to be. But until you get there, you won't know and you'll wonder. That's OK. Wonder! But in all your wonderment, *trust*." —Natalie

"Just. Do. It. Wake up, order some curriculum, put your index finger on Day One and *go*! Then, wake up the next day and *Just. Do. It*. Again. And again and again and again. I wish someone had told me that when you stop thinking about it and start doing it, you realize that you can do this! And when you think you can't continue? Reach out. Co-ops. Classes. Friends. Find others to vent to and allow your children to study with. Then keep trucking. Wondering and worrying can be your homeschool's biggest enemies. Prayer, persistence, and confidence are the keys to a happy homeschool—not the perfect curriculum, not a decked-out classroom, not a shiny blog. You and your children, learning and being together every day. *That* is what it takes. And that is what I'll be doing for many years to come!" —Elizabeth

"Take time once or twice a year to look at what you've accomplished, to consider your goals as a family, to evaluate where your children are. Be intentional about your decision and about your commitment to it. It's like the biblical parable of the man who built his house on sand and the one whose home was built on the rock. If you base your homeschooling decisions on temporary frustrations or a whim or the expectations or beliefs of others, you may find that when the storms come (and they will), your resolve crumbles like that house built on the sand. Start with a firm, solid foundation like rock, and you will have the strength to press on despite the storms and trials." —Stephanie

"Remove all preconceived ideas about what school should look like and spend some time thinking about your definition

of education. Identify your core nonnegotiables and plug them into your routine. Then live your extra hours reading, talking, exploring, and playing as a family. It will come together." —Heidi

"If you are thinking about starting homeschooling, I would highly recommend taking the plunge. The truth is, you will never have all your questions answered. You will never feel fully capable. You *will* have fears. Not everyone will support your decision. And you will question your sanity a hundred times over.
And yet it is a gift to you, your child, and your family." —Heather

"Every human being is a genius because we were created in the image of God. Your job is to find that genius and inspire each individual in that direction. It may sound daunting, but know this: God is on your side. How do I know this beyond the shadow of a doubt? Because he gave you your kids, knowing that you were the person with the ability to cultivate and inspire within them the things they would need in order to be world-changers.

This isn't a race, and there isn't a timeline that is 'do or die.' Life has seasons, and an ebb and a flow. No one is a superhuman." —Teri

"Remember that in a perfect world, we'd all wake up with boundless energy, have a clean house, enjoy grateful children who love to help, and the laundry wouldn't pile up. There is no perfect world, at least not all at the same time. So, refocus on why you started homeschooling in the first place, go back to what works, and let go of what doesn't. Simplify, simplify, simplify, until you can get your feet back under you."
—Georganne

"Homeschooling is always better if you are relaxed. It is OK to take a break. A few weeks will not change your child's ability to learn. Seek out ways to make school fun for both you and your child." —Tabitha

"The greatest advantage to homeschooling is the ability to disciple your children each and every day without the disadvantage of exposure to worldviews that differ greatly from your own. Don't worry, don't be afraid, don't think about all the deficits you think you have. No one loves your children more or cares as much about their education than you. When God calls, He will equip. Believe Him." —Marcy

"Find some other homeschoolers to hang out with! I can't stress enough how important it is to have other homeschoolers to talk to. They don't even have to be local; find an online homeschool community and take part in the conversation. Ask questions, read what you can from other homeschoolers, but always take care not to compare yourself with other families. You are doing what you are doing for the love of your children. Always remember that, and you'll be a successful homeschooler." —Joy

"Relax! The times I've felt the most overwhelmed were when I was trying to be all things to all people. You can't do it all. This year, I hired a housecleaner to clean once a week. We could afford it, and it took one thing off my to-do list. Don't look at what everyone else is doing and think you have to do it all, too. If you are overwhelmed, just stick with the basics. Eventually, you'll have time to cover more subjects, but it doesn't have to be every day of every year." —Toni

"If I could give someone one piece of advice, it would be to look at your homeschooling journey as just that—a journey.

You don't need to jump in and have the 'perfect' year the first year. There's plenty of time to course-correct and make changes as you go.

That's not an excuse to be lazy and let your kids' academics suffer because 'there's always next year.' It's just a realistic view as you compare what you're doing with what other people are doing and notice holes in your lessons.

Reevaluating as you go is healthy, but look at it as an opportunity to do better and put new ideas into practice, not as a reason to get discouraged!" —Mandi

"Any time I get to thinking I should do our days like this person or that person, it fails . . . we have to stick to what works for our own family!" —Lindsey

"A homeschool mom who says she's never been burned-out is l-y-i-n-g, plain and simple. The key is not to throw in the towel because you've hit a rough patch. If you've written down your goals or mission statement, now is the time to pull it out and remember why you started down this road in the first place. It is not said enough to parents of elementary-age and younger kids, but I absolutely promise you that the academic portion of your homeschool day is the least important element of the whole operation. No matter how fabulous you are, no matter how wonderful your curriculum, your younger children will not remember much of what you're teaching them. You have to be careful not to focus so much on the academics that you unknowingly give your kids public school at home rather than the individualized, whole-life education you set out to provide." —Danielle

"You won't know how to do it at first, but that's OK. You will learn along with your kids, which is an amazing experience that most parents miss out on." —Leo

"To borrow a well-known line, just do it! Slow down in life and enjoy your children. They have years and years of responsibility ahead of them, and these are years for learning, exploring, and finding their way. Let them be kids." —Nicole

# Homeschooling Contributors

**Mandi Ehman (case study, chapter 2 quote, encouragement):**
Mandi Ehman is an entrepreneur, online publisher, and author who is passionate about encouraging other women to live intentionally. She's the blogger behind LifeYourWay.net, the author of *Easy Homemade*, and the founder of BundleoftheWeek.com. Mandi and her husband have four spunky little girls plus one baby boy, and together they live, work, and homeschool on a little slice of heaven in wild, wonderful West Virginia.

**Marcy Crabtree (case study, chapter 6 quote, scheduling, encouragement):**
Marcy spent nearly fifteen years as an ObGyn nurse, sometimes juggling homeschooling with the job she calls her first ministry. Grateful that her main ministry today is at home, she has been married to Tom for sixteen years and is the proud momma to Ben. Her homeschool style is delight directed (just a hair shy of unschooling), using mostly unit studies and greatly influenced by Charlotte Mason's love of living books. If she ever writes a book herself, it's likely to be titled *Homeschooling by the Field Trip Method*. Although Marcy resides in Kentucky, she loves to travel

wherever and whenever given the opportunity (more research for that book!). You can find Marcy blogging at BenAndMe.com.

**Carisa Hinson (case study, chapter 5 quote, scheduling):**
Carisa is a homeschooling mom of three, ages eleven, seven, and four. She is also a full-time, inner-city missionary living in one of America's toughest neighborhoods with her husband. They have lived and served in this area for over nine years and have no plans to leave. She writes at 1plus1plus1equals1.com, where she gives readers a behind-the-scenes look at her family and how homeschooling works for them.

**Natalie Klejwa (case study, chapter 4 quote, scheduling, encouragement):**
Natalie is wife of twenty years to Joe and home-educating mother to nine. She is the founder of Visionary Womanhood Gatherings in the Twin Cities, Minnesota, area, administrator of VisionaryMotherhood.com, author of VisionaryWomahood.com, co-author of *The Heart of Simplicity: Foundations for Christian Homemaking*, contributing writer for KeeperOfTheHome.org, and owner of AppleValleyNaturalSoap.com.

**Stephanie Langford (case study, chapter 1 quote, scheduling, encouragement):**
Stephanie has a passion for encouraging homemakers who want to make healthy changes and carefully steward all they've been given. She has written with her handsome husband, *Plan It, Don't Panic: Everything You Need to Successfully Create and Use a Meal Plan*, geared to helping families live more naturally and eat real, whole foods; is mama and teacher to four little ones; and is the editor and author of KeeperOfTheHome.org.

**Heather Sanders (case study, chapter 11 quote, encouragement):**
Heather is a leading homeschooling journalist who inspires homeschooling families across the nation. Married to Jeff, Heather lives in the East Texas Piney Woods and homeschools her three children, Emelie, Meredith, and Kenny. She blogs at HeatherSanders. com and is a contributing writer for ThePioneerWoman.com

**Teri Helms (case study, chapter 7 quote, scheduling, encouragement):**
Teri is the mother of five, fabulous boys ranging in age from twelve to twenty-five. She is extremely grateful for one incredible husband! Her family lives in Southern California. The Helmses have home-educated all their children since birth and believe that education prepares you for your real vocation and calling in this life rather than simply securing a job. Teri blogs three days a week at www. TommyMom.com, where she celebrates her family culture while keeping it real and richly humorous and highlights leadership, its tenets and principles, and individuals practicing it effectively. Through all this, she hopes to communicate that people are worth more than anything else, that anyone willing to invest in relationships can homeschool, too, and that freedom is a gift.

**Bambi Moore (case study, end of chapter 6, scheduling):**
Bambi is a simultaneous saint and sinner, redeemed and justified by the blood of Jesus. She has been the helpmate to her high school sweetheart for eighteen years, and they have eight arrows they are sharpening, ages seventeen to infant. Bambi spends her days managing a busy, joyous, and *loud* household. She enjoys homeschooling, reading storybooks in a rocking chair, keeping the pantry stocked, changing diapers to the glory of God, and a million other duties she wouldn't trade for the world. Bambi blogs about God's beautiful design for womanhood in marriage, motherhood, and family discipleship on her blog, InTheNurseryOfTheNation.com.

**Leo Babauta (case study, chapter 9 quote, encouragement):**
Leo Babauta is a former journalist of eighteen years, a husband, father of six children, and in 2010 moved from Guam to San Francisco, where he leads a simple life as a simplicity blogger and author. He created ZenHabits.net, a top twenty-five blog (according to *TIME* magazine) with 260,000 subscribers, mnmlist.com, and the bestselling books *Focus*, *The Power of Less*, and *Zen To Done*.

**Lee Binz (case study, chapter 8 quote):**
Lee and her husband Matt homeschooled their two sons from elementary through high school. Upon graduation, both boys received four-year, full-tuition scholarships from their first-choice universities. This enables Lee to pursue her dream job: encouraging parents as they homeschool their children through high school. Her free minicourse, "The 5 Biggest Mistakes Parents Make When Homeschooling High School," is a great introduction to high school essentials. You will find Lee online at TheHomeScholar.com.

**Tabitha Philen (chapter 10 quote, scheduling, encouragement):**
Tabitha, known as "Penny" to her readers at MeetPenny.com, is a saved-by-grace wife to one terrific husband and homeschooling mother to four amazing children, including her oldest who has an autism spectrum disorder. Tabitha strives to live a transparent life and openly shares her attempts to balance family, time, and budget.

**Elizabeth Schmidtberger (case study, end of chapter 7, encouragement):**
Liz is a career-oriented, material girl-turned-debt-free homeschooling housewife. She is married to her high school sweetheart, Keith, and together they have four young boys. She loves Jesus and strives to love others as He loves her and teach her children that same lesson. She is just starting out on her homeschooling journey but wouldn't have it

any other way. She loves blogging, fishing, being with her boys, and watching the *Today* show. Find her at TheHesitantHousewife.com.

**Jen Vawter (end of chapter 1):**
Jen is a wife and mom of two kiddos living in rural Yelm, WA. A former high school math teacher, she now finds great joy (and sometimes frustration!) in homeschooling her kids where they are currently using My Father's World and All About Reading materials. When she's not with her children, Jen is also a certified childbirth educator (ICCE) and certified birth doula (CLD) and enjoys teaching childbirth classes at her local Care Net pregnancy center. Jen blogs at BirthyTeacherMom.blogspot.com.

**Nancy Sathre–Vogel (case study, encouragement):**
Nancy is a modern-day nomad who wanders the globe in search of adventure and beads. Along with her husband and children, she spent many years teaching school in various countries, and then spent four years living and traveling on bikes. Now, she lives in Boise, Idaho encouraging others to head out and live their dreams. She blogs at FamilyOnBikes.org.

**Kristen (scheduling, encouragement):**
Kristen writes about cheerfully living on less on her blog, TheFrugalGirl.com. She works hard to create a happy life on a budget for her husband and four kids, and is passionate about simplicity, photography, homeschooling, eco-friendly living, and Jesus.

**Heidi Scovel (case study, scheduling, encouragement):**
Heidi documents "Living Lovely" at her blog, MtHopeAcademy. blogspot.com. There she celebrates (in words and images) her journey as wife, homeschooling mother of three rambunctious boys

and a darling girl, photographer, book collector, sentence diagramer, and lover of the little things.

**Joy Miller (case study, encouragement):**
Joy is the wife of Jeff and mom to three more Js—Jaden, Jerah, and Joely. She and her husband have been homeschooling their children since 2005, when their children were three, six, and eight. Joy works from home as a web/graphic designer (fivejsdesign.com) and homeschool blogger (fivejs.com) and spends what little free time she has with her nose buried in a good book. Joy's motto for parenting, homeschooling, and even business is, "Give a man a fish and you feed him for a day. Teach a man to fish and you feed him for a lifetime."

**Toni Anderson (scheduling, encouragement):**
Toni is the founder of TheHappyHousewife.com, cofounder of DigitalCoLab.com, and a consultant for Savings.com. When she isn't helping others become better managers of their homes, she loves spending time with her family, homeschooling her kids, and exercising.

**Danielle Zigmont (scheduling, encouragement):**
Danielle is a big-city Southern California girl who, after a number of years spent enjoying the majesty of small-town Montana, relocated back home to be near extended family and make a go of her homesteading dreams. She's married to her stud of a high school sweetheart, and together they're raising three handsome, rough-and-tumble young men. Their family loves the Lord and homeschooling is just one of the many ways they have endeavored to give their whole lives to Christ. Danielle loves to read, cook, organize, hike in beautiful weather, and spend entirely too much time playing with all things tech-ish. Danielle and her family are having a blast working to turn their healthy "do-it-yourself" spirit into a more self-sufficient

lifestyle. You can find her blogging at TheHandcraftedHomestead.com.

**Wendy Hilton (case study, scheduling):**
Wendy lives in the South with her wonderful hubby and three great kiddos. She is a Christian, homeschooling, work-from-home mom. She and Scott were high school sweethearts and have been married for more than twenty years. Her oldest child (age eighteen) has autism, and Wendy began homeschooling her at age two. Her son (age sixteen) is a typical teenage boy and would rather do anything than school! Her youngest child (age ten) is a little social butterfly and people person. Wendy loves reading and quilting and hopes to return to scrapbooking soon. You can visit her at HipHomeschoolMoms.com where she is co-owner, or you can find her on her personal blog (which occasionally gets updated) at Wendy-HomeschoolingBlessings.blogspot.com

**Kerry Beck (end of chapter 2):**
Kerry has worked with moms, teachers, and homeschoolers the past thirty years. She graduated three kids who are all on their own. As an empty nester, Kerry enjoys meeting with young moms to encourage them in raising, educating and encouraging their own kids. She would like to give you a free ebook, *Everything You Wanted to Know About Homeschooling* at her site: HowToHomeschoolMyChild.com

**Nicole (encouragement):**
Nicole is a transplanted Brit cross South African, technically a lily white African American with an accent. Retired marketing expert with the gift of the gab, capable of huge fund-raising and a penchant for decorating homes across the globe. She offers unlimited advice on infertility, adoption, transracial families, and parenting. Nicole is married to her soul mate, an atheist, "because," she says, "I suspect he fears an afterlife with me." She blogs at bywordofmouthmusings.com.

## Jill Britz (case study):

Jill is a wife, mom of four lovelies (ages ten down to one), writer, reader, and practical homemaker. She loves vintage things, bookstores, blank paper, and the smell of her baby's breath. She is married to a self-employed dreamer, and together they make a homemade life along a river in rural Wisconsin. Jill writes at TinyAndSmall.wordpress.com.

## Kelly Crawford (case study):

Kelly is wife to Aaron and homeschooling mama to ten children. They live a simple but busy life in the South, loving the Lord, and on a mission to find the perfect cottage industry. Kelly has authored numerous articles in homeschooling magazines, speaks to women about her family's experience, and has been featured on *Generations With Vision* and several other radio broadcasts. She has written several ebooks to help moms carry out the important task of raising the next generation. You can find a wealth of practical encouragement and inspiration for your day and your life at her blog, GenerationCedar.com.

## Linsey Knerl (case study, chapter 2 quote, scheduling):

Linsey is a homeschooling mom of five living in rural Nebraska on four acres. She blogs about home education and rural living at LillePunkin.com.

## Michael Ramey (the legal side):

Michael is Communications Director for ParentalRights.org. He holds a BA in Foreign Language with an emphasis in Spanish from Virginia Commonwealth University, and a Master of Divinity with Biblical Languages from Southeastern Baptist Theological Seminary. An ordained Southern Baptist minister, Ramey honed his communication skills through thirteen years of church ministry

before joining the staff of ParentalRights.org. Michael lives in Winchester, VA, with his wife Rachel and four beautiful children.

### Abigail Gehring (case study, scheduling):

Abigail is executive director of production at Skyhorse Publishing in New York City. She's the author of more than a dozen books, including *The Homesteading Handbook*, *The Illustrated Encyclopedia of Country Living*, and *Odd Jobs: How to Have Fun and Make Money in a Bad Economy*. She homeschooled from first grade all the way through high school, along with her big brother. She currently divides her time between New York, New York and Windham, Vermont.

### Beth Snyder (case study):

Beth was raised in Kansas and Wyoming, where she was taught to appreciate nature and wildlife, even at its smallest, mundane, or seemingly insignificant. After college in Nebraska, she married Mark, farmer and accountant. Together, their homeschooling goal is to raise children who lovingly serve their Creator and value His book of nature.

### Georganne Schuch (chapter 8 quote, chapter 11 quote, encouragement):

Georganne and her husband Brad are entering their tenth year of homeschooling and forging ahead into the murky waters of high school. They have five daughters (ninth grade, sixth grade, third grade, kindergarten, and preschool). It's a rocky ride some days, but every day is a blessing. They recently transitioned from city life to country life in Central Texas. She blogs about homeschooling, homemaking, and life in general at MomToManyGirls.com.

**Michelle Schackow (chapter 4 quote):**
Michelle is a homeschooling mom of fifteen years. She and her husband Joe homeschool their six children so they can have the best Christian education possible. They have been blessed with Ashley, Bethany, Lindsey, Joseph, Holley, and Joshua. As a family, they enjoy boating and other outdoor activities, and most importantly, spending time together.

**Rhonda Hill (chapter 10 quote):**
Rhonda lives on her hobby farm with her husband and two daughters near Two Harbors, MN. She enjoys grandchildren, many hobbies, and blogging. Her blog is called Cozy Cottage and Simple Living. You can find it at mckenzygirl.blogspot.com.

**Marisa Miller (case study):**
Marisa Miller is an aspiring photographer and writes at her blog GraceMothering.com. She lives in Texas with her husband, four children, nine chickens, a welsh corgi, and three cats.

**Lindsay Tyson (chapter 1 quote, chapter 4 quote, encouragement):**
Lindsay currently lives in Chiang Mai, Thailand. She has been married to her amazing husband, Tracy, for twelve years. They have five wonderfully unique children: Elia (eleven), Jude (seven), Timothy (four), Xili (two), and Evangeline who was just born September 2013. Lindsay and Tracy are busy learning Thai, loving and raising their children, and asking the Lord to use them to help plant thriving church bodies in districts where there are very few believers and no churches. Lindsay enjoys homeschooling their three boys and training their first little daughter, Xili. Above all things, her desire for her children is that they would faithfully follow the Lord Jesus Christ.

# Acknowledgments

I think the acknowledgments are possibly the most fun part of writing the book. They are the "story" behind the book, the chance for the author to explain a bit more about the process.

Usually the acknowledgments start with "I could never have written this book without . . ." I used to always read these words and think it sounded like false modesty. There are still some authors who I believe are brilliant and could spit out books easily on their own, but I can honestly say I am not one of them. So when I say, "I could never have written this book without . . .," it is the truth.

First, let me give you a bit of back story. The idea for this book started a few years ago in the summer of 2012. To be honest, I was feeling a bit burned-out on homeschooling. I knew it was the right choice for my family, and my kids were progressing academically, but we were all sick of school. I wouldn't say I was ready to quit, but I was needing wisdom and encouragement. I knew of several bloggers who were homeschooling and had been for many more years than I, and I wanted to be able to ask them questions. I was also, slowly, starting to understand more of the bigger homeschool picture, the true mission of what I wanted my kids to learn, and how that couldn't be measured by academics alone. I knew others had their purpose much more "ironed out" than I did.

So I came up with the brilliant idea of creating a compilation book of homeschoolers answering "real-life" homeschooling questions.

This was a brilliant idea for two reasons. First, it would be able to benefit more people than just me. I figured many other people who were starting or burning out with homeschooling had the same questions and would love to hear some real-life encouragement. Second, I was much more likely to have people respond to me if I were writing a book than if I were just some random person asking questions.

My idea worked, and in August of 2012 *You Can Do It Too– 25 Homeschool Families Share Their Stories* was published. It was over eighty thousand words of raw research data (formatted and professionally edited so it was easy to read). But it was choppy, wonderful for an "around the living room chat," but I wanted to see it paired with some homeschooling information. The goal was always to encourage homeschoolers, to focus on the basics, to not get burdened with curriculum and being perfect, and to enjoy the few years we have our kids at home. However, with this encouragement and real-life examples, there could also be an overview of the homeschooling world with narrative that would tie things together (such was the goal at least).

I plugged the idea to my editor at Skyhorse Publishing (who published my book *Simple Living Handbook* in April of 2013), and she went for it. For someone who has almost failed out of English and everything related to it in school my entire life, this was so exciting. I am never short of words, but getting them out in the right order, spelled right, or using words with more than six letters has always been a challenge to me.

I started the book you're now holding.

But then life got really crazy. My family, who had been traveling for work during the months of December 2012 and January 2013 while the book was being ironed out, decided to move to China during the month of February. We had three weeks from when we got back from our traveling work assignment until the time we

would fly across the ocean, and we had to get rid of all our stuff and tie up all the loose ends. The book was put on hold.

Then we got to China and everything was new and crazy and I didn't have any time to work. The book was put on hold again.

During the spring months, I just couldn't see any way I was going to be able to get to this book project, and I wrote to my editor and told her I just couldn't do it.

We got settled here in China, and I just couldn't get the book out of my head. After a quiet weekend of soul searching and prayer, I came back to the idea of encouragement I had needed myself so much the year before. A few weeks opened up at the end of the semester, and I jumped in. Writing the majority of a book that should take months during a three-week time period was wild. But I am so glad I did. I love looking back through these pages and feeling encouraged all over again.

So now for the thanks.

There is no way I could have written this book without . . .

The homeschool families who responded to my interview requests both last year and this year. Reading through these families' stories, circumstances, journeys, and dreams brings tears to my eyes, and I love each and every one of them (seriously, they feel like family even though I have met very few). They were willing to open themselves up and be honest about the successes and the failures, the dreams and the struggles. The encouragement they have given me in my own homeschooling journey has been amazing, and I am so excited to share them with you as well. Without these wonderful families, there would be no book. We are all in this together, and we can encourage each other so much.

My family. My husband has always believed in me, both with writing and with homeschooling . . . neither are things I would have had the confidence to do on my own. My husband has taught me the difference someone who believes in you can make, and I am inspired to pass this power on to my children and others I meet. As far as

my kids, they have lived through my homeschooling learning curve (which isn't done yet) and still love me.

My editor Abigail and Skyhorse Publishing for believing in me enough to let me try this project . . . even for a second time after I backed out and for fixing all the issues with grammar, word order, spelling, and grown-up words. They have been so great to work with from the very beginning, and I am so honored to publish under their name.

My friend Brenda Eitel who initially told me I was a quitter when I backed out earlier in the spring and then provided encouragement (and distraction) on Skype while I was working on the book. She has promised me pizza and cheesecake when I get back to the United States.

I want to thank God for everything he has done in the creation of this book, our homeschooling journey, and my whole life, but I can't figure out a way to say it without it sounding dumb and cliché. In reality it is a gross understatement, and all the credit of this book, and anything my life might produce or in any way positively influence, needs to go to Him.

# Real-Life Homeschooling

This book project started with my curiosity about how other homeschoolers were doing. I knew the ideals and I knew none of us were perfect, but I wanted more of a picture of what was really going on. I knew this would help me and others who were looking at homeschooling or struggling with it.

The interview project became *You Can Do It Too – 25 Homeschool Families Share Their Stories*.

If you wish you could sit in a living room (with a nice cup of tea and a pastry) and ask veteran homeschooling parents the hard questions like:

1. How and why did you decide to start homeschooling?
2. When you started, what did you know about homeschooling?
3. What does your typical school day look like?
4. What was a really successful day? What about a terrible day?
5. Have you thought about quitting before?
6. What curriculum do you use and why?
7. What are your favorite parts and least favorite parts of homeschooling?
8. How has the home school schedule affected/benefited your family life?

9. **How do you know if you are successful or not in your homeschooling?**

... and more, this is the book for you (without the tea and pastries, unfortunately).

*You Can Do It Too – 25 Homeschool Families Share Their Stories* is a huge resource book with over eighty thousand words of their answers. Much of the research, case studies, and quotes I have used in this book came from the research I gathered for *You Can Do It Too*.

I am a story person, I love ideas, but I want to see what they look like in practice, in real life, when the dog gets sick or the washing machine breaks. I want to know other people are real just like me. If you need more real answers and more of the story, grab *You Can Do It Too – 25 Homeschooling Families Share Their Stories* on Amazon.

# About the Author

Lorilee Lippincott is a child of God, wife, mom, teacher, writer, minimalist, and traveler. Her husband, Bryon, is a professional photographer, and still just as dreamy as when they first met. After working in management for a few years, she left to take care of her kids (now ages seven and ten) and work with her husband on entrepreneurial projects. Lorilee believes that life is too short to try and live someone else's life or be afraid of doing new things.

Several years ago, Lorilee and her family simplified their lives, their material possessions, their living space, and their financial needs. These changes have allowed her more time for living, teaching, and writing.

The Lippincotts spent time living in China teaching English, spent a few years living and working in Cambodia, and are now settled in northern Thailand.

**You can find Lorilee online at her blog –**
**LovingSimpleLiving.com**

# Also by Lorilee Lippincott

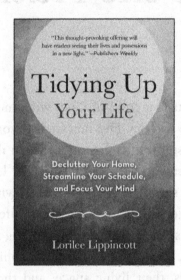

Lorilee is also the author of *Tidying up Your Life*, where she talks about stripping away expectations and habits that reflect others instead of you. With a laid-back, easy tone, she addresses material clutter, not as a way of cutting back or denying yourself, but as a way to free up your life and space for what you truly love. Going beyond material clutter, she also addresses overcommitment, time, money, and other areas of clutter and stress that crowd out the life we want to live.

# Endnotes

1. 2009 Report—http://hslda.org/docs/study/ray2009/2009_Ray_StudyFINAL. pdf—chapter 1
2. http://www.thehomescholar.com/CollegeAdmissionBook—chapter 1
3. http://www.ted.com/talks/ken_robinson_says_schools_kill_creativity.html— chapter 2
4. http://familyonbikes.org/store/—chapter 2
5. https://www.stephencovey.com/7habits/7habits.php—chapter 3
6. http://www.welltrainedmind.com/—chapter 4
7. (http://www.welltrainedmind.com/classical-education/)—chapter 4
8. http://en.wikipedia.org/wiki/Montessori_education—chapter 4
9. http://en.wikipedia.org/wiki/Waldorf_education—chapter 4
10. http://www.amazon.com/The-Successful-Homeschool-Family-Handbook/ dp/0785281754—chapter 4
11. http://store.tjed.org/product/books/thomas-jefferson-education/paperback— chapter 4
12. http://www.tjed.org/about-tjed/7-keys/—chapter 4
13. http://www.welltrainedmind.com/—chapter 5
14. http://www.simplicityparenting.com/—chapter 6
15. http://simplelivinghandbook.com—chapter 7
16. https://www.stephencovey.com/7habits/7habits.php—chapter 7
17. http://hslda.org/docs/study/ray2009/2009_Ray_StudyFINAL.pdf—chapter 8
18. http://hslda.org/—chapter 8
19. http://hslda.org/—chapter 9
20. http://www.simplicityparenting.com/—chapter 10

21. http://richardlouv.com/books/last-child/—chapter 10

22. http://richardlouv.com/books/last-child/—chapter 10

23. http://www.hslda.org/docs/nche/000010/politicsofsurvival.asp—chapter 12

24. http://www.hslda.org/laws/—chapter 12

25. http://www.hslda.org/about/—chapter 12

# Index